A HANDBOOK OF CHINESE ART

A HANDBOOK OF
CHINESE ART

for collectors and students

by

MARGARET MEDLEY

*Curator of the Percival David
Foundation of Chinese Art*

BELL & HYMAN
LONDON

Published by
BELL & HYMAN LIMITED
Denmark House
Queen Elizabeth Street
London SE1 2QB

First published in 1964 by
G. Bell & Sons Ltd
Third edition 1977
Reprinted 1979

ISBN 0 7135 0258 4

Printed and bound in Great Britain by
REDWOOD BURN LIMITED
Trowbridge & Esher

PREFACE

The terminology of the arts and crafts of Europe is generally well known, a number of excellent handbooks, primers and guides, easily available to amateurs and students, having been published over the last few years. In the field of Chinese art we are less well provided for despite the publication of Professor S. Howard Hansford's *Glossary of Chinese Art and Archaeology*, which is primarily intended for the student with some knowledge of the Chinese language and characters. The present handbook assumes no such familiarity, representing as it does an attempt to fill this gap for the general reader. The terms included are, in the main, limited to those which one might encounter in any book on Chinese art written in English. Terms are briefly, and I hope clearly, explained, and wherever possible illustrated in the line drawings associated with the seven sections into which the book is divided.

The study of Chinese art and culture is an expanding one, and to attempt a comprehensive dictionary of art terms and iconography would be beyond the power of any one person. In the present instance it will be found that the sections on Buddhism and painting are subject to severe limitations, such as are perhaps less obvious, but which nevertheless exist, in the other sections. One omission will inevitably be noticed by those concerned with ceramics. This is the absence of all but reign marks from the illustrations, the only other marks included in either illustration or text are those which may be used as both marks and decorative motives. It seemed to me that ceramic marks form a subject for study on their own, and that they should be dealt with in a separate publication.

In order to compensate for these limitations an introductory note is included with each subject, and at the end of each section a short list of useful books has been added, which will, I hope, prove helpful to those wishing to delve more deeply into the subjects in which they are interested. Only books in English are

included, but many of these will be found to quote from sources in other languages, especially in French and German. An admirable example of such a book is Martin Feddersen's *Chinese Decorative Art*.

In compiling the text I have drawn on many sources, but the most useful single works for their own sections were Soothill and Hodous' *Dictionary of Chinese Buddhist Terms*, Benjamin March's *Some Technical Terms of Chinese Painting*, and the *Chieh-tzŭ yüan hua chüan*, 'The Mustard Seed Garden manual of painting'. From this last work, of the late 17th century, I have been able to take all the illustrations for the section on painting. The illustrations are also from many sources, some are redrawn, others original. Of those that are redrawn I must thank Professor Hansford for permission to use a number from his *Glossary*, and at the same time acknowledge a debt to Miss Helen Fernald's *Chinese Court Costume*, for some decorative motives. In the preparation of the Bronze section I have been grateful for the help of Mr. A. H. Christie, who has kindly supplied the introductory note for that section. I have received much help, patiently given, and advice from friends and colleagues, and hope that the book will prove useful to some, at least, of those who have so generously given me their time.

MARGARET MEDLEY

CONTENTS

ILLUSTRATIONS

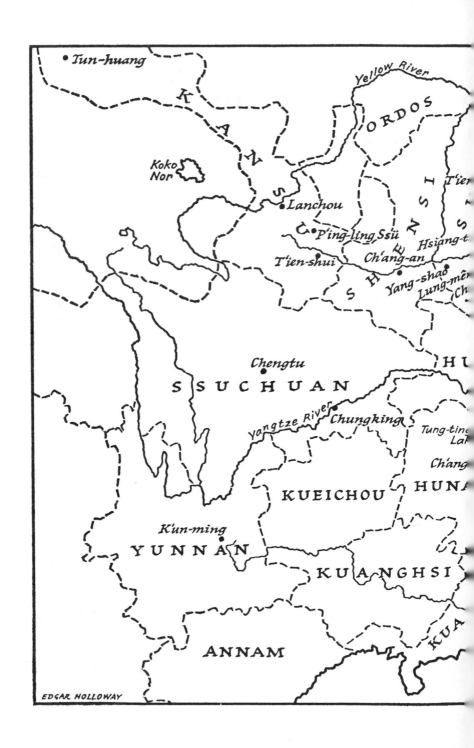
EDGAR HOLLOWAY

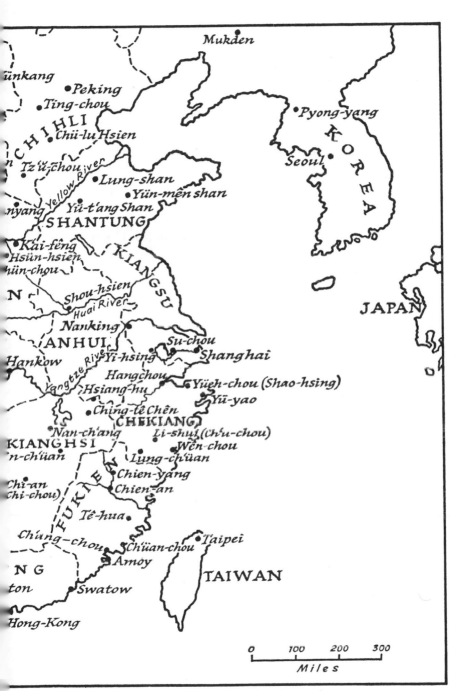

Mukden

ünkang
•Peking
•Ting-chou

Pyong-yang•

CHIHLI

•Chü-lu Hsien

KOREA

Tz'ü-chou River

Seoul•

nyang

Yellow River

•Lung-shan

•Yün-mên shan

•Yü-t'ang Shan

SHANTUNG

•Kai-fêng

KIANGSU

•Hsün-hsien

ün-chou

JAPAN

•Shou-hsien

N

Huai River

•Nanking

•Su-chou

ANHUI

•Yi-hsing

Shanghai

Hankow

Yangtze River

•Hangchou

•Hsiang-hu

•Yüeh-chou (Shao-hsing)

•Yü-yao

•Ching-tê Chên

CHEKIANG

•Nan-ch'ang

•Li-shui (Ch'u-chou)

KIANGHSI

•Wên-chou

n-ch'üan

•Lung-ch'üan

Chi-an

•Chien-yang

Chi-chou)

•Chien-an

FUKIEN

•Tê-hua

•Taipei

Chüng-chou

•Chüan-chou

N G

•Amoy

TAIWAN

ton

•Swatow

•Hong-Kong

0 100 200 300

Miles

See overleaf for Key to the map

KEY TO THE MAP

Archaeological sites

Anyang (Honan), Bronze Age
Ch'ang-sha (Hunan), Bronze Age
Chêng-chou (Honan), Bronze Age
Hsün-hsien (Honan), Bronze Age
Lung-shan (Shantung), Neolithic
Shou-hsien (Anhui), Bronze Age
Yang-shao (Shensi), Neolithic

Buddhist sites

Hsiang-t'ang Shan (Honan)
Lung-mên (Honan)
Lung-shan (Shantung)
P'ing-ling Ssü (Kansu)
T'ien-lung Shan (Shansi)
T'ien-shui (Kansu)
Tun-huang (Kansu)
Yü-t'ang Shan (Shantung)
Yünkang (Shansi)
Yün-mên Shan (Shantung)

Ceramic centres

Chi-an (Kiangsi)
Chien-an (Fukien)

Chien-yang (Fukien)
Ching-tê Chên (Kiangsi)
Chü-lu Hsien (Chihli)
Chün-chou (Honan)
Hsiang-hu (Kiangsi)
Ju-chou (Honan)
Li-shui (Chekiang)
Lin-ch'üan (Kiangsi)
Lung-ch'üan (Chekiang)
Nan-ch'ang (Kiangsi)
Tê-hua (Fukien)
Ting-chou (Chihli)
Tz'ŭ-chou (Chihli)
Yi-hsing (Kiangsu)
Yü-yao (Chekiang)
Yüeh-chou (Chekiang)

Historic ports

Amoy (Fukien)
Canton (Kuang Tung)
Ch'ang-chou (Fukien)
Ch'üan-chou (Fukien)
Shanghai (Kiangsu)
Swatow (Kuang Tung)
Wên-chou (Chekiang)

CHINESE DYNASTIES AND REIGNS

SHANG (YIN) *c.* 1500 – *c.* 1028 B.C.

CHOU *c.* 1027–249 B.C.

Warring States 481–221 B.C.

CH'IN 221–206 B.C.

HAN 206 B.C.–A.D. 220

SIX DYNASTIES A.D. 221–589

SUI 581–618

T'ANG 618–906

FIVE DYNASTIES 907–960

SUNG 960–1279

YUAN (Mongols) 1280–1368

MING 1368–1644

Hung-wu	1368–1398	Hung-chih	1488–1505
Chien-wên	1399–1402	Chêng-tê	1506–1521
Yung-lo	1403–1424	Chia-ching	1522–1566
Hung-hsi	1425	Lung-ch'ing	1567–1572
Hsüan-tê	1426–1435	Wan-li	1573–1619
Chêng-t'ung	1436–1449	T'ai-ch'ang	1620
Ching-t'ai	1450–1457	T'ien-ch'i	1621–1627
T'ien-shun	1457–1464	Ch'ung-chêng	1628–1643
Ch'êng-hua	1465–1487		

CH'ING 1644–1912

Shun-chih	1644–1661	Tao-kuang	1821–1850
K'ang-hsi	1662–1722	Hsien-fêng	1851–1861
Yung-chêng	1723–1735	T'ung-chih	1862–1873
Ch'ien-lung	1736–1795	Kuang-hsü	1874–1908
Chia-ch'ing	1796–1820	Hsüan-t'ung	1909–1912

NOTE ON PRONUNCIATION

The pronunciation of Chinese words is fairly straightforward if the following selection of approximate equivalents is followed.

Initial consonants

ch, k, p, t, ts, and tz are hard, as j, g, b, t, ts, dz in English.

ch', k', p', t', ts', tz', are all soft as in ch-, k-, p-, t-, ts-, dz-, in English.

hs, is a soft S produced by placing the tip of the tongue against the front lower teeth.

j, resembles the French *je*, but is very slightly rolled like an R.

ssŭ is like a long hissed S before 'sir'. For practical purposes tgŭ is somewhat similar.

Vowels

a, is always long.

ai, is like 'aye' in English.

ao, is 'ow' as in 'cow'.

ê, ên, and êng, with the ê usually resembling the French *eu* as in 'fleur'.

e, or eh, as in French *é*.

i, as 'ee' in 'see'.

ih, has no good English equivalent, with the first syllable of 'cheroot' being perhaps the nearest.

o, almost equivalent to English 'or'.

ou, as in 'although'.

u, like oo.

ü is narrow like the French *u* in 'tu'.

BRONZES ✩

Although, as Dr. Joseph Needham has shown, cast iron played a major role in China many centuries before its use in the West became general, it was copper in various alloys which provided the main material for the makers of metal vessels, mirrors and the like, coins, as well as weapons down to Han times at least. The alloys were cast, in fired clay moulds, in cast iron moulds, and also by the *cire-perdue* method, and were finished when cold by various standard metalworking techniques.

Copper (melting-point 1,083 degrees Centigrade) occurs widely in China. The metal in its pure form is rather soft, but alloyed with tin to make bronze its hardness is substantially increased, while the melting-point is lowered, a fact which facilitates its working. Conventional Eurasiatic bronzes show a fairly constant proportion of 10 per cent of tin. In China, however, the tin content varied considerably and the practice of adding lead to the alloy was common. This further reduced the melting-point and produced an admirable casting metal which was rather softer than the 10 per cent tin alloy. The lead which, unlike the added tin, does not dissolve in copper, remains suspended in globular form in the melt and, by improving the flow, greatly reduces the risk of surface bubble flaws in the casting. A lead-tin alloy has the additional advantage of being easier to work with gravers and chisels when cold. Chinese casters also made use of copper-lead alloys, particularly in coinage, where its use may be ascribed to economic rather than technical considerations.

In typical simple alloys the tin content of early Chinese bronzes

runs from 12 to 20 per cent. Lead may be included in these up to 20 per cent, while in the case of copper-lead alloys, the proportion of the latter may be as high as 30 per cent.

Animal Combat Motive is associated with the art of the pastoral nomads of the Eurasian Steppe, including the Chinese region of the Ordos Desert. The motive consists of two fairly evenly matched opponents such as two stallions, or a tiger and an eagle, in violent combat. The interpretation of the motive is vigorous and strongly linear. [1*a*]. *See* ORDOS.

Animal Style. *See* ORDOS.

Animal Triple Band is a variant of the *k'uei* dragon (q.v.) in which the creature is distributed into three bands, the top one containing the crest, or horn; the second band, the eye, ear and part of the body, and the third one containing the nostril, lower jaw, foot or claw, and the lower part of the body. As a decorative element it is confined to Shang and Early Chou. [1*b*].

Animal Tsun, a wine vessel in the form of an animal. [1*i*]. Many are known, and perhaps the commonest is the elephant *tsun*.

The opening of this type of vessel is always in the centre of the back. Confined mainly to Shang and Early Chou, it re-appears in the Huai style (q.v.) in a modified form.

Animals of the Four Quarters are commonly found on bronzes and lacquers of the Han period. They are; the Sombre, or Dark, Warrior [1*c*] (a tortoise with a snake coiled round the body), representing the North and Winter; its colour is black; the Green Dragon [1*f*], representing the East and Spring; the Scarlet Bird [1*e*], representing the South and Summer, and the White Tiger [1*d*], representing the West and Autumn.

Axes, called *yüeh*, *ch'i* or *fu*, are either tanged or socketed [1*h*]; the socketed type is more varied in that the socket varies in length from a tube to a ring. Both types generally have decorated tangs protruding from the back of the shaft, and, in the Shang period examples, these may be ornamented with turquoise inlay.

PLATE 1. BRONZES. *a*] Animal Combat Motive. *b*] Animal Triple Band. *c-f*] Animals of the Four Quarters. *g*] Belt Hooks. *h*] Axes. *i*] Animal Tsun. *j*] Bird Tsun.

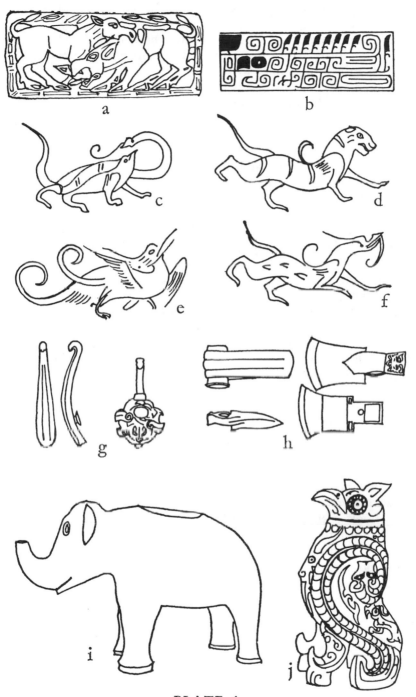

PLATE 1

The blades vary from a simple spatulate form, that may be ribbed, to a form similar to the European battle-axe, with a wide arc-shaped blade, which is sometimes decorated, and is also occasionally perforated. The tanged type are mainly datable to Shang and Early Chou; the socketed type is current throughout the whole Bronze Age.

Belt Hook, a hook with a straight or slightly curving shaft, with a stud at one end for fastening into the belt, the hook at the other end to catch a link. [1g]. The shaft may be ornamented along its whole length, or only at the stud end, farthest from the hook. In profile they often show a gentle, beautifully proportioned S-curve. They vary considerably as a type from the long and slender to the short and stubby, often with a large butt end, that may carry very complex decoration, which may be gilt, inlaid with gold, or silver, or turquoise, or with several of these together. The hook itself may be in the form of a bird's head, the goose being particularly common. They do not appear to have been made before the 6th century B.C. (in Huai style), and cease sometime towards the end, or soon after the end of the Han period. The Chinese name is *tai-kou*.

Bent Ear Handles spring from the body of the vessel below the rim, round which they are bent upwards. They make their appearance in late Shang times and become a common feature in Middle Chou.

Bird Tsun, a wine vessel in the form of a bird, the head of which in Shang and Early Chou examples forms the cover [1j]; the owl seems to have been the commonest bird in these two periods. In Huai style examples, when the type is revived, using as a rule the goose or pheasant, the opening is in the centre of the back.

Bottle Horns occur both on *t'ao-t'ieh* masks (q.v.) and on *k'uei* dragons (q.v.). The horn resembles a chianti bottle with a slightly flared mouth; found only in Shang and Early Chou.

Broad Figure Band, an element of Middle Chou decoration, which occurs in many variations, all of which seem to derive ultimately from animal forms. [2a].

PLATE 2. BRONZES. *a*] Broad Figure Band. *b*] C and T Decoration. *c*] Chia. *d*] Chiao. *e*] Chüeh. *f*] Chien. *g*] Chien sword. *h*] Chêng. *i*] Cicada. *j*] Chung. *k*] Chih.

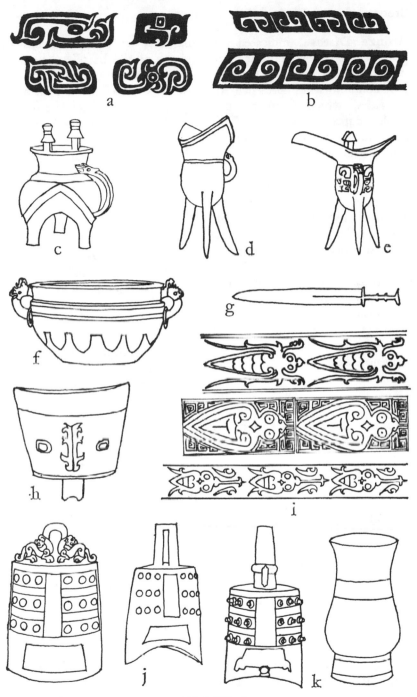

a

b

c

d

e

f

g

h

i

j

k

PLATE 2

Bronze Disease, indicated by pale green powdery spots or lines, is the destruction of the alloy by the contaminating presence of chlorides, which form an unstable cuprous chloride. This continues to react even under ideal museum conditions, and to halt the destructive action of the chlorides, it is necessary to eliminate them. Cuprous chloride is not only insoluble in water, but may also be inaccessible in its greatest concentration in the deep layers of the incrustation. Chemical treatments are known and used in museum laboratories specialising in conservation, but treatment of a bronze is no guarantee that a further outbreak may not occur.

Cabriole Leg, swelling and rounded at the top with a slender, slightly curving mid-section. Typical of the Middle Chou period, when it makes its appearance, and of the Huai and Han bronze vessels.

C and T Decoration, a term introduced by Karlgren to distinguish one element, which, found together with several others, is covered by the general name 'thunder pattern' (q.v.). It occurs only in the Shang and Early Chou periods. [2*b*].

Chêng, a clapperless bell of elliptical section, the long diameter of which exceeds the height of the barrel. There are no bosses, and the decoration usually consists of *t'ao-t'ieh* masks (q.v.) on each side. The straight handle is short and hollow, perhaps for mounting on a pole. Confined to Shang and Early Chou. Some modern Chinese authorities attach the name *nao* to this type. [2*h*].

Ch'i. *See* AXES.

Chia, a wine vessel somewhat resembling the *chüeh* (q.v.) but generally larger and without spout or backward extending lip. It has instead a wide circular or rectangular mouth with two capped columns diametrically opposed and at right angles to the handle lip axis. In some cases the legs may be hollow at least part of the way down. One small group is rectangular with four legs, and capped columns on the centre of the short sides; there may in this type be a cover with a bird-form handle in the centre. The vessel is confined to the Shang and Early Chou periods. [2*c*].

Chiao, a wine vessel very like the *chüeh* (q.v.) but without capped columns; the spout is replaced by a second extended lip. If a cover survives it is usually found to be in the form of a bird in flight, or of an animal. The *chiao* only occurs in the Shang and Early Chou periods. [2*d*].

Chien, a deep, wide, circular basin, with two or more handles, which may be ornamented with animal heads and fitted with rings. The vessel was either filled with water, for use as a mirror, or was filled with ice in which perishable foods were stored. The latter view is supported by modern Chinese opinion, following an early text. It is also suggested that it was used for washing in, as was the *p'an* (q.v.). Surviving examples are of the Huai period only. [2*f*].

Chien, a bronze sword about 2 feet, or 2 feet 6 inches in length with a narrow smoothly tapering blade having a pronounced central rib. The largest on record is 3 feet in length and the shortest 7 inches, both exceptional. There was no crosspiece and the hilt was small and slender, with two thickened bands of metal, equally spaced along it. The pommel of the sword was often so fashioned as to accept an ornamental disc of jade. In some cases the point of junction between the blade and the hilt was decorated with a jade fitting. This type of sword was common in the Late Chou period and during the Han Dynasty. [2*g*].

Chih, a drinking vessel with a slightly flared mouth and fairly wide belly, usually circular in section, but occasionally oval. The hollow foot is generally splayed. Decoration tends to be rather restrained on this type of vessel, which is confined to the Shang and Early Chou periods. The name *chih* for this vessel was first applied in the Sung Dynasty, and it is not certain that it is correct. [2*k*].

Ching. *See* MIRRORS.

Chio. *See* CHIAO.

Chiu. *See* KUEI.

Chronology. *See* PHASE.

Chüeh, a wine vessel with a body of narrow elliptical or circular section. It has a large open spout for pouring, and opposite this a flattened and extended lip; there is a loop handle on the side of the body. The vessel stands on three legs of triangular section, that spread a little. At the root of the spout are two short capped columns, one on each side. If the vessel bears an inscription, this generally appears on the body under the loop of the handle. The flattened elliptical type is the more primitive form, and for the most part pre-dates the finds at Anyang, and is perhaps datable to a period before 1350 B.C. The type as a whole was no longer made after the end of the Early Chou, and it is possible that most of the surviving examples are of

Shang date. The decoration may be sparing or extremely lavish, and flanges (q.v.) sometimes extend up the spout and on the extended rear lip. [2e].

Ch'un. See Tuɪ.

Chung, a bell. It occurs in three forms, all elliptical in section, and narrowing a little towards a flat top. [2j]. In the first form there is a shaft rising from the centre of the flat top, and near the base of the shaft is a loop for suspension. The second type has a narrow rather tall loop in the centre of the flat surface; and the third type has a complex loop consisting of two confronted animals, sometimes with their heads turned back over the shoulder. A graduated series of these *chung* could be hung up as a chime in a stout wooden frame, and sets of up to 16 are known. Very large examples, measuring about 3 feet in height, were usually hung up alone, and were named *t'ê-chung,* 'special bell'. The surface of the bell is divided into three main panels on each side, with a decorative zone at the bottom. The central panel, narrowing towards to the top, was usually left plain, or carried an inscription; the two wider panels on either side of this were ornamented with three rows of three bosses each, which in late examples might appear as coiled serpents, making a grand total of 36 bosses. The bells were struck with small bronze or wooden drumsticks. This type of bell is believed by some Chinese writers to have been made in the Shang period, but the earliest surviving examples date from Middle Chou. Examples with complex animal loops only occur in the Huai style.

Cicada, a decorative motive of the Shang and Early Chou styles. It varies from the most realistic representation to the most stylised; in its realistic form it may be used as a banding element, and in its stylised form usually occurs in Hanging or Rising Blade decoration (q.v.). [2i].

Coiled Beast Motive consists of a feline curled up with its head to its own tail, sometimes with the feet, ears and tip of the tail similarly ornamented, with a repetition of this motive on a minute scale. [3a]. The objects on which the motive appears are usually small and suitable for personal adornment or as harness ornaments, studs and buttons being the most common. The

PLATE 3. BRONZES. *a*] Coiled Beast Motive. *b*] Gourd Hu. *c*] Cosmic Mirror. *d*] Fu. *e*] Flat Hu. *f*] Ho. *g-h*] Hanging Blade Decoration. *i*] Ho, Huai type. *j*] Fang-i. *k*] Hill Jar.

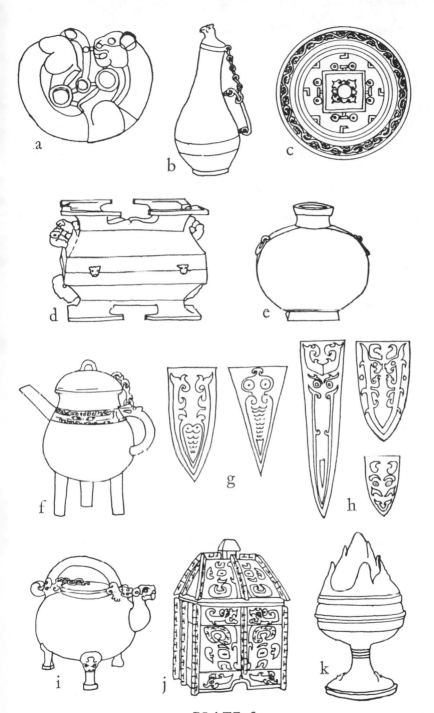

PLATE 3

motive is associated with the art of the Ordos (q.v.).

Compound Lozenge with Spikes. A rectangular decorative element, having from two to four lines on each side, with a circular boss or spike in the centre. It occurs in the main field of decoration in the Shang and Early Chou periods only. The term was introduced by Karlgren in 1949.

Cosmic Mirrors are those on which the most prominent elements of decoration on the back resemble the letters T, L, and V, with the Animals of the Four Quarters interspersed between them and probably with the Twelve Branches (q.v.) arranged round the central boss; with the Animals of the Four Quarters other smaller birds and animals, and perhaps *hsien* (q.v.) may be included. The symbolism of these mirrors is complex, and is fully discussed by Yetts in *The Cull Chinese Bronzes*, (London, 1939). This type of mirror dates from the Han period. [3c].

Dragons. *See* K'UEI DRAGONS.

Drums are of two main types. The first is a barrel set horizontally on a stand, the ends closed with hide; one celebrated example of Shang date is made entirely of bronze, the closed ends being cast with a pattern that simulates crocodile skin. The second type, made entirely of bronze, with a wide horizontal striking surface, has a slightly waisted cylindrical body; the drum head is, in some cases, ornamented with four crouching frogs. The type is associated with the bronze cultures of Yünnan and North Vietnam and date from about the 3rd century B.C. onward. The Chinese associate this drum with the name of the Three Kingdoms hero, Chu-ko Liang.

Early Chou, the name given by Karlgren to the style current in the bronze art of the period between *c*. 1028 and *c*. 900 B.C. This style is a continuation of that of Shang (q.v.) with certain modifications such as 'bent ears' (q.v.), hook projections (i.e. flanges (q.v.) that become elaborately broken up), birds with plume-like tails, and finally the introduction of the *p'an* (q.v.). This style is so much dependent upon that of Shang, that the distinction between them is often difficult to make, but generally speaking the Early Chou style is more elaborate and flamboyant, and the forms are often heavier, lacking something of the simple monumentality of the earlier period.

Fang-i, a rectangular casket-shaped vessel with a cover resembling a hipped roof, which is surmounted by a knob of similar

shape. A peculiarity of the foot is the presence of a semicircular notch in the middle of the lower edge of each side. The vessel does not appear to have been named in the inscriptions and the name it now bears was given in the Ch'ing period. It is usually regarded as a vessel for the storage of grain, but one modern Chinese authority holds that it should be included among the wine vessels. It is confined to Shang and Early Chou, and the decoration is usually lavish, consisting of t'ao-t'ieh (q.v.) and k'uei dragons (q.v.). A few specimens carry only one or two narrow bands of S-spiral pattern (q.v.). [3*j*].

Flanges are vertical rib-like projections often occurring on vessels of the Shang and Early Chou periods; they may be segmented, a phenomenon more common in Early Chou than in Shang examples. Contrary to the belief held by some people that these flanges are an aid to good casting, they are in fact a disadvantage, since they make the moulds more complicated, but there is no doubt that they serve to make the junctions of the moulds less obvious, as any roughness in the finished product can be rubbed down easily, without in any way harming the decoration. In the Middle Chou style they occur only on *Li* (q.v.) and are then reduced to little more than fins.

Four-petal Flower Pattern. *See* SQUARE WITH CRESCENTS.

Flat Hu, a vessel, rectangular in section, the body being moon-shaped, with ring handles mounted on the narrow shoulders. The mouth is circular, but the foot rectangular. This unusual variation of the standard *hu* (q.v.) appears about the 5th or 4th century B.C. and continues into the Han period. [3*e*].

Fu. *See* AXES.

Fu, a rectangular food vessel with four angular feet at the corners. The cover is almost identical, the only difference being, in some cases, the addition of two loop handles on the short sides; like so many covers, it can be reversed on removal and used as another dish. This class of vessel was introduced in Middle Chou. [3*d*].

Glutton Mask. *See* T'AO-T'IEH.

Gourd Hu, a variation of the *hu* (q.v.), shaped like an elongated gourd, circular in section. Instead of ring handles, it has a chain fixed low down on the body, the other end meeting the body just below the lip; the cover, where this survives, is sometimes in the form of a squatting bird. The type only occurs in the Huai style (q.v.). [3*b*].

Green Dragon. *See* ANIMALS OF THE FOUR QUARTERS.

Hai-ma P'u-t'ao, literally, sea-horses and grapes, a name given to a type of bronze mirror produced in the T'ang Dynasty; perhaps better known as Lion and Grape mirrors.

Hanging Blade Decoration, a long narrow leaf-shaped motive, the tip of which is directed downwards; it is usually filled with cicada [3g] (q.v.), or with a variant of the *t'ao-t'ieh* [3h] (q.v.), with or without a spiral background. Rising blade decoration is the same, but with the tip directed upwards. The motive belongs mainly to the Shang and Chou periods, but recurs on 18th and 19th century bronzes and cloisonné imitating objects of antiquity. The terms were introduced by Karlgren.

Hill Jar, or hill-censer, called in Chinese *po-shan-lu*. In bronze these are surmounted by a roughly conical cover with holes, so cast and decorated as to resemble hills piling up to a central peak. The holes occur behind each rising hill, and through these the incense could emerge. [3k]. The hemispherical bowl, in which the incense was placed, was supported in various ways from the wide flat-bottomed bowl; the support might be a simple column, a bird with outspread wings, or even a boy balancing the incense bowl on his hand stretched up above his head. The 'hill' was often decorated with animals and hunting scenes, and a few examples are inlaid with gold. The type is confined to the Han Dynasty and its origin is obscure; two possible explanations have been put forward; first, that the mountain form represents the Five Sacred Mountains of China, and second that it represents Mount Sumeru, the sacred mountain of the Buddhists. *See also* CERAMICS, Hill Jar.

Ho, a wine kettle on three or four legs, which in some cases are hollow; the handle at the back is invariably surmounted by an animal head; the straight spout is of medium length. The cover is generally linked to the body by a short chain. When the vessel bears an inscription, this appears both on the body and on the inside of the cover. [3f]. This class of vessel occurs in all stylistic periods, but Huai style examples differ from the earlier ones in three respects; first, the legs are of the cabriole type (q.v.); second, the handle is arched over the cover, and third, the spout is S-curved, and terminates in an animal's gaping jaw or bird's beak. [3i].

Hook and Volute, a motive used as a background filler, and occasionally as a border motive on

inlaid bronzes, in the Huai style. It is a triangular hook with a tight curl at one end.

Hsi, a general name for a large bowl or basin, with everted rim, probably intended for ablutions. Below the rim outside there may be two mask-mounted handles, or lugs with ring handles. This type of vessel may also be called *p'ên*.

Hsien in bronze decoration are semi-human figures, often termed immortals, with plumes flying out behind them from the upper arm and shoulder, and from the thigh. They occur in this form most commonly in the Han period.

Hsien (vessel). *See* YEN.

Hsü, a rectangular vessel for food, with rounded corners. The body curves inwards a little towards the mouth and the foot, and the cover carries on the curving line initiated in the contour of the body; on the cover are four cumbersome-looking spurs, which, when the cover is removed and reversed, form feet. On the short sides of the body are two handles, often surmounted by animal heads; the splayed foot is sometimes replaced by four animals. The vessel occurs only in Middle Chou and a modern Chinese authority suggests that it was gradually absorbed into the *kuei* class (q.v.). [4*d*].

Hu, a wine storage vessel current throughout the Bronze Age and continuing into the Han period. In Shang and Early Chou two types were common. One was tall and slender, often with a cover that could be reversed and used as a bowl; this type was circular in section and often rather sparingly decorated. [4*b*]. The other type was elliptical in section, rather more heavily made and usually richly decorated with *t'ao-t'ieh* (q.v.). [4*a*]. Both types have cylindrical fittings on the neck for a carrying cord. In Middle Chou the vessels are often circular in section, with a larger belly than the earlier ones, and there were ring handles suspended from animal lugs on the neck. [4*c*]. In the Huai style, the ring handles are sometimes replaced by vigorous animal handles set vertically. Both Middle Chou and Huai style examples were richly decorated. In the Han period, the decoration ceases to be an integral part of the casting, and ring handles return, suspended now from mask fittings. *See* SQUARE HU, FLAT HU and GOURD HU.

Huai Style is the name given by Karlgren to the style of bronze decoration current from about 600 B.C. until the beginning of the Han Dynasty in 206 B.C., the point in time conventionally regarded as marking the end of the Bronze Age, although iron had been in

increasing use, for agricultural and military purposes, through the greater part of this period. The name Huai derives from the region of the Huai River, to the north of the Yangtze River, where finds of objects in this new style were first made; the term must not be taken to mean a purely local style, but one that was common to a large part of North and East China. The decoration of this final period of the Bronze Age is complex. Especially characteristic of it are the intricate interlocking and overlapping patterns, sometimes based on geometrical motives, sometimes on animal forms. The *t'ao-t'ieh* (q.v.), with its prominent eye-balls and gaping jaw, reappears, but instead of being in the form of two confronted beasts seen in profile, as so often in the Shang and Early Chou, it is now seen only as a full face view of an animal mask. There is great enrichment in detail and surface, and the dragon forms assume a serpentine quality not seen in earlier styles. Some of the patterns have names such as rope pattern, plait pattern, cowrieshell, hook and volute, scale pattern, dot filling, and triple lozenge, most of which are self-explanatory. (*See* TRIPLE LOZENGE and HOOK AND VOLUTE.)

The standard of craftsmanship is generally of a high order.

I, a water ewer, bearing a strong resemblance to the old-fashioned sauce boat. [4e]. It appears first in the Middle Chou period and stands on four ornamented legs; examples made in the transition period between the Middle Chou and the fully developed Huai style, may have slender S-curving legs, and in the mature Huai style there is either a foot-ring, or no foot at all. The handle is generally ornamented with an animal head, the mouth biting the rim of the vessel; late examples may only have a simple ring handle. The spout of the Huai style type is sometimes in the form of a feline head with gaping jaws.

Interlocked T's, an element of Shang and Early Chou decoration in which the stem of each T forms one half of the crossbar of another. [4f].

Jingles are of two kinds. The simplest kind is an openwork sphere, containing a small bronze ball, surmounting a socketed shaft to fit on harness, or on a chariot. The more complex form has two of these openwork spheres with balls, each on an arched shaft

PLATE 4. BRONZES. *a–c*] Hu. *d*] Hsü. *e*] I. *f*] Interlocked T's. *g*] Ladle. *h*] K'uei Dragons. *i*] Jingle. *j*] Ko. *k*] Ku. *l*] Kuang.

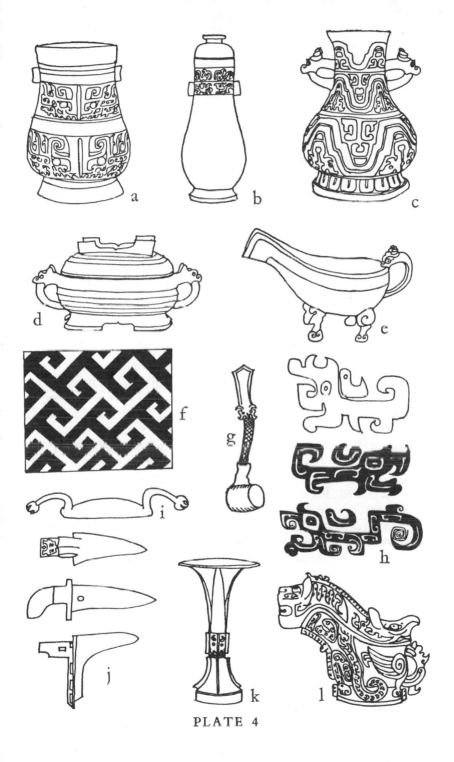

PLATE 4

rising from each end of a bow-shaped bronze mount. The precise purpose of this more complex type is not known, but it seems likely that they were fixed to the front of the chariot as guides for the reins, and *not*, as the Chinese have recently suggested, for use with the reflex bow of the Shang and Early Chou periods from which they date. [4*i*].

Ko, a bronze dagger-axe, either socketed or tanged, hafted at right angles to the shaft. In either case the weapon has a characteristic projection to the rear of the shaft; this projection (*nei* in Chinese) is either straight and roughly rectangular, or droops in a slight curve. The *nei* is often decorated, and Shang examples are sometimes found with turquoise inlay. In Middle Chou and Huai the weapon undergoes a radical change in form, the lower edge being extended backwards and downwards in a curve, to continue as a prolongation of the blade parallel with the shaft; in the Han period there may be a similar extension upwards. In Huai examples both blade and *nei* may be inlaid with gold. In the Han period the weapon is rather slender and the main blade, instead of being at a strict right angle to the shaft, may be cast with a slight inclination upwards. [4*j*].

28

Ku, a tall, slender vessel with trumpet mouth, narrow body and high splayed foot. A peculiarity of this vessel is the pair of cruciform perforations that occur in a narrow undecorated band between the splayed foot and the central zone of decoration; the significance of these is not known, but it has recently been suggested that there may be technical reasons for their presence. *Ku* is thought to be a vessel for drinking, but the name may be wrongly associated with this shaped object. The type dates from Shang and Early Chou only. [4*k*].

Ku. *See* DRUMS.

Kuang, a jug-shaped vessel, elliptical or rectangular in section, on a slightly splayed foot. The spout is wide and the cover often overhangs the edge; the handle may be large and elaborate. The cover is usually in the form of an animal's head and back, with the jaws over the spout; in elaborate examples another head may occur at the back, and sometimes, when this happens, the lower part of the jug represents the lower part of the animal, with the limbs and claws forming part of the decoration. Some examples have a ladle, which fits through a slot in the handle end of the cover. The decoration is often lavish; the type occurs only in Shang and Early Chou. [4*l*].

Kuei, a deep circular food vessel, with spreading lip and foot-ring. It generally has two handles, sometimes four, and very rarely none [5a, b]; the handles are usually surmounted by animal heads. One small group stand fixed to a massive cube-shaped plinth. The decoration varies from the simplest to the most ornate. The vessel occurs in all periods of the Bronze Age, but is less common in that of Huai. The Middle Chou vessels, which are sometimes termed *chiu*, usually stand on three small feet [5c]; some specimens of this period have covers.

K'uei Dragons. Small dragon-like animals, with open jaws, seen in profile, as a secondary element in bronze decoration. They are referred to by Karlgren simply as 'dragons', and he enumerates nine main types in connection with the Shang and Early Chou styles. [4h]. They occur in a modified form in the Middle Chou style, and become somewhat serpentine in the Huai style, by which time their original identity has been lost, although the term may be retained for the sake of convenience.

Ladles, associated mainly with the Shang and Early Chou periods, are like cylindrical dippers on the end of long, well-ornamented handles having a slight S-curve.

In later times these bronze ladles were probably superseded by lighter ones made of pottery or lacquer. [4g].

Lei, a wine, and perhaps water, vessel, either circular or rectangular in horizontal section. It has wide sloping shoulders, with ring handles suspended from mask-surmounted lugs; the lower body tapers elegantly to a hollow foot. In the case of the round bodied type, the cover is domed and has a small knob; the cover of the rectangular type closely resembles that of the *fang-i* (q.v.). On the lower part of the body are animal heads in relief, from which there sometimes hang rings. Shang and Early Chou, but some Chinese writers suggest that the round type also occurs in Middle Chou. [5h].

Lei-wên. *See* THUNDER PATTERN.

Li, a vessel, with three hollow legs, in which food was heated. [5d, e]. The form of this vessel, which is peculiar to China, derives from a pottery prototype of the Neolithic period, and perhaps in its ceramic form common to the Eurasiatic land mass. It is basically three conical vessels merged together into one about half-way up the total height. This design meant that the greatest possible area was exposed to the heat of the

fire. It may have been used in conjunction with a 'steamer' (see *Yen*). It was common to Shang, Early Chou and Middle Chou, and perhaps Huai. In Shang and Early Chou the handles rose directly from the rim, but in Middle Chou they often sprang from below the rim and were bent round and upward.

Lien, a cylindrical vessel on three small feet in the form of squatting bears; there is usually a cover with a ring handle in the centre. A large number of *lien* are undecorated, others are gilt, and some are inlaid with gold and perhaps other metals. The vessel is said to have been used for cosmetics, and appears first in the Huai style. [5*i*].

Ling, a small bell of elliptical section, not unlike the Swiss cowbell, with a loop for suspension or holding in the hand. This type is said to have been used for both ceremonial and military purposes in Shang and Early Chou. [5*f*].

Lion and Grape Mirrors. *See* HAI-MA P'U-T'AO.

Mao. *See* SPEARHEADS.

Middle Chou, the name given by Karlgren to the style current in bronze art between *c.* 900 B.C. and *c.* 600 B.C. Many of the forms and decorative motives differ fundamentally from those of the earlier periods. Certain new vessels such as the *Fu* (q.v.), *I*, (q.v.) and *Hsü* (q.v.) are introduced; the *Kuei* (q.v.) undergoes radical modification by being raised on three or four feet; the *Li* (q.v.) becomes arched under the belly, and the *Ting* (q.v.) becomes shallower and in many cases widens towards the rim. The *Chung* bell (q.v.) is introduced. Other changes include the replacement of cylindrical legs by S-curved legs, resembling the cabriole leg, exhibiting quite different proportions. Flanges (q.v.) become little more than fins and occur only on the *Li* (q.v.) spiral horns, scale bands, vertical scales, wavy line, broad figure bands are the main decorative motives (for examples see appropriate entries). A number of vessels disappear altogether; these are the Square *Ting, Li-ting, Ku* and *Tsun, Fang-i, Chüeh, Chia* and *Chiao,* and the *Kuang.*

Ming, an almost spherical vessel with short cylindrical mouth and foot, and mask-mounted ring handles on the shoulder. Only one of these vessels has been

PLATE 5. BRONZES. *a–c*] Kuei. *d–e*] Li. *f*] Ling. *g*] Shan Mirror. *h*] Lei. *i*] Lien. *j*] Scale Bands. *k*] P'ou. *l–m*] P'an.

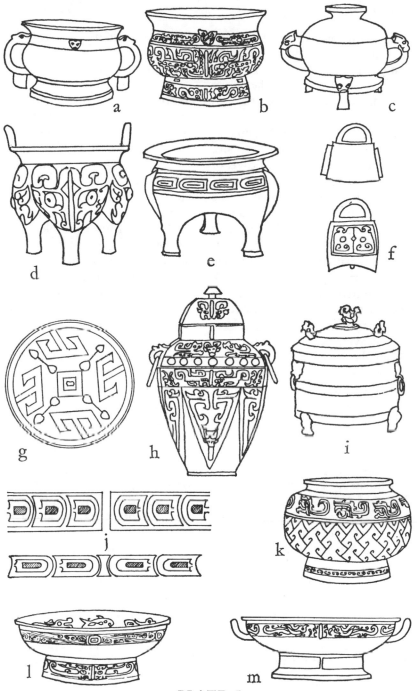

PLATE 5

certainly identified by its inscription; this was the one found in the tomb of the Marquis Ts'ai in An-hui, dating from the Huai period. It was undecorated.

Mirrors of high-tin bronze appear first in the 6th or 5th century B.C. Prior to this date bronze bowls of clear water known as *chien* (q.v.) are said to have been used. The true mirror, a metallic reflecting surface with decorated back, was at first small, thin, and very light, with a small fluted loop on the back for the passage of a silk cord. Most mirrors are circular but a few are square. As time went by the mirrors became larger, thicker and heavier, and the loop was gradually transformed into a round boss. The rim of the Han period mirror was often wide and thick; this characteristic continued until the T'ang Dynasty, when the whole artistic atmosphere changed. The large central boss remains, but the rim may be lobed or foliated. No mirrors were inscribed before the Han period, when the practice suddenly became very popular, especially on Cosmic Mirrors (q.v.); in T'ang times inscribed mirrors are comparatively rare. After T'ang there are few bronze mirrors, but those that survive rely partly on T'ang tradition in design, and partly on free pictorial design; some are still circular; a straight handle running out from the rim is also found.

Nao. *See* CHÊNG.

Nei. *See* KO.

Ordos. The semi-desert region within the great bend of the Yellow River. The relics of the art of this region are associated with the Bronze Age animal style common to Southern Siberia, the whole Central Asian steppe and South Russia to the shores of the Black Sea. Most examples of the bronze art of the Ordos are small, intended for personal adornment or as harness ornaments; knives and short swords also display animal style elements on the hilt, especially in the ibex head terminals; the human form rarely appears. The style, the precise place of the origin of which is uncertain, is common to the nomadic races of the whole Eurasian plateau and goes back into remote antiquity. Examples of the style are extremely difficult to date with any precision owing to the long persistence of motives. In China they range from about the 5th century B.C. to about the 5th century A.D. or later. The two best known and most persistent motives in this animal art are known as the Animal Combat Motive (q.v.) and the Coiled Beast Motive (q.v.).

P'an, a wide circular, shallow bowl raised on a spreading foot and used for washing the hands

[5*l*]; there are sometimes handles of the bent ear type (q.v.). [5*m*]. Karlgren is of the opinion that the type does not occur before Early Chou, but recent finds suggest that some could be earlier. A few early examples are decorated inside as well as outside.

Patina. Bronze patina, familiar to, and much admired by collectors, is the result of exposure to oxidizing conditions, either of burial, or of atmosphere. The first oxide layer, which is purplish or red in colour, is called cuprite. This may later become encrusted with carbonates that are blue or green in colour, and correspond to azurite or malachite. Owing to inadequate poling, or imperfect mixing of the alloy, there are often considerable variations in the colour and texture of the patina on any one piece. There are a number of problems in this connection that have to be solved by future research. *See* WATER PATINA and BRONZE DISEASE.

P'ên. *See* HSI.

Phase. In 1936 W. P. Yetts proposed a division of early Chinese bronzes into three phases. His system has been widely adopted in Great Britain, but less commonly in the rest of Europe. In Sweden and America Karlgren's classification and chronology have been generally employed. In the present book a classification based on that of Karlgren has been used, but the term Shang (q.v.) has been preferred to Karlgren's Yin. The appropriate equivalents are:
First Phase: Shang (Yin) and Early Chou.
Second Phase: Middle Chou.
Third Phase: Huai Style.
Descriptions of the main characteristics of each of the four styles in the second column may be found under the appropriate entry.

Pien Hu. *See* FLAT HU.

Plait Decoration, an element in Huai style decor.

Po-shan-lu. *See* HILL JAR.

P'ou, a large round vessel, contracted at the mouth and finished with a plain rim, the foot is very slightly splayed. Confined to Shang and Early Chou, but a few may be later. [5*k*].

Preying Animal Motive, like the Coiled Beast Motive (q.v.), is associated with the races of nomadic origin to be found in the whole area from the shores of the Black Sea to the great bend in the Yellow River. The motive consists of a predatory bird or animal attacking another animal, usually though not invariably of a herbivorous species; thus an eagle or

tiger attacking a stag or buffalo. [6a]. The motive is interpreted with extraordinary sympathy and pathos. *See* ORDOS.

Rising Blade Decoration. *See* HANGING BLADE DECORATION.

Rope Pattern, an element of Huai style decoration.

Scale Band, an element in Middle Chou decoration, the scales being arranged horizontally in bands. [5j].

Scarlet Bird. *See* ANIMALS OF THE FOUR QUARTERS.

Shan Mirrors are a type in which the main element of decoration resembles the Chinese character *shan*, 'mountain'. The element is repeated four or five times round the central loop, with the long horizontal bottom stroke towards the centre. This type is datable to the 4th and 3rd century B.C.; they are never inscribed. [5g].

Shang, the name, based on that of the first historical dynasty, given to the style of the bronze art of the period *c.* 1500–1028 B.C.; called Yin by Karlgren (the two names are inter-changeable) in his

papers *Yin and Chou in Chinese Bronzes* (1935) and *New Studies in Chinese Bronzes* (1937), in which he set out his criteria for the classification of bronze styles and their chronology. The chief vessels current in this period are the *Ting*, including the Square *Ting*, *Li-ting*, *Yu*, *Ku* and *Tsun*, *Fang-i*, *Chüeh* and its related forms *Chia*, *Chiao*, and the *Kuang*; these continue into the next period, Early Chou, after which all except the *Ting* disappear (see the appropriate entries). Karlgren names 33 decorative motives, of which the most important are the *t'ao-t'ieh*, cicada, bird, whorl circle, hanging blades and rising blades, 9 types of dragon, circle bands, square with crescents, interlocked T's and various spiral motives, mostly of the thunder pattern type. For details see the appropriate entries.

Sino-Siberian Style. *See* ORDOS.

Sombre Warrior. *See* ANIMALS OF THE FOUR QUARTERS.

Spearheads of the Shang Dynasty were generally wide-bladed and of the socketed type. [6c]. After the Shang period the head takes on narrow leaf shape, which generally becomes more slender in the last few centuries B.C.,

PLATE 6. BRONZES. *a*] Preying Animal Motive. *b*] Spoon. *c*] Spearheads. *d*] Square with Crescents. *e-f*] S-Spiral Patterns. *g-h*] T'ao-t'ieh.

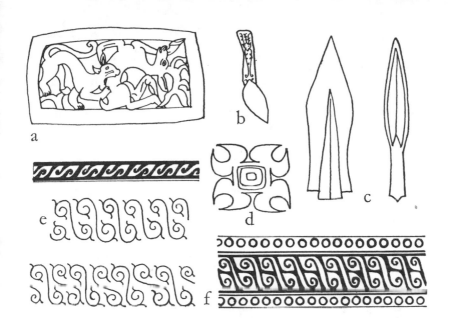

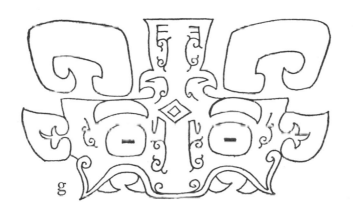

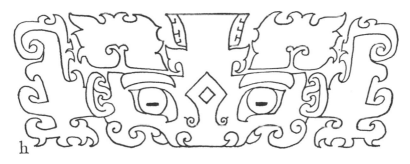

PLATE 6

acquiring an elegance, which conceals the strength imparted by the powerful central rib and the steep bevel of the edges. The sockets of those made just before and during Han times might be decorated and carry a small loop, from which would flutter a plume or tassel.

Spiral Horns, an element of Middle Chou decoration occurring on free standing animal heads.

Spoons are well known among the bronzes of the Shang, Early Chou and Middle Chou periods. They are rather flat with a fairly short, wide handle, usually richly ornamented; they may be based on originals made of shell. [6b].

Spring and Autumn Annals, Period of. This term in connection with bronze design and decoration is no longer current, since the period covered by the Annals does not coincide with a single style, but includes some pieces of Middle Chou style and some of the Huai style. The term is, however, still found in some Chinese publications and in older books in European languages.

Square Hu, a rectangular type of *hu* (q.v.) with mask-mounted ring handles. Decoration is sometimes wholly dispensed with in this type; at other times the casting provides for inlay of gold, silver, copper, turquoise or malachite, or combinations of two or more of these materials. The rectangular lid, where this survives, has either a central ring handle, or four lugs at the corners. These vessels were not produced before the Huai period. [8i].

Square with Crescents is essentially a square with large arcs cut out of the four corners [6d]; there is usually a small circular boss in the centre. The Chinese name for this motive is *ssŭ-pan hua-wên*, 'four-petal flower pattern', but its origin is probably not floral.

S-spiral Pattern usually occurs as a band of S-forms placed very closely together; this is the best known form; or it may occur as a variant in the background filling known as Thunder Pattern (q.v.). [6e, f].

Ssŭ-pan Hua-wên. See SQUARE WITH CRESCENTS.

Tai-Kou. See BELT HOOKS.

T'ao-t'ieh is the name of an animal mask motive. It is one of the most important decorative motives, associated mainly with Shang and Early Chou, and occurs

PLATE 7. BRONZES. *a-d]* T'ao-t'ieh.

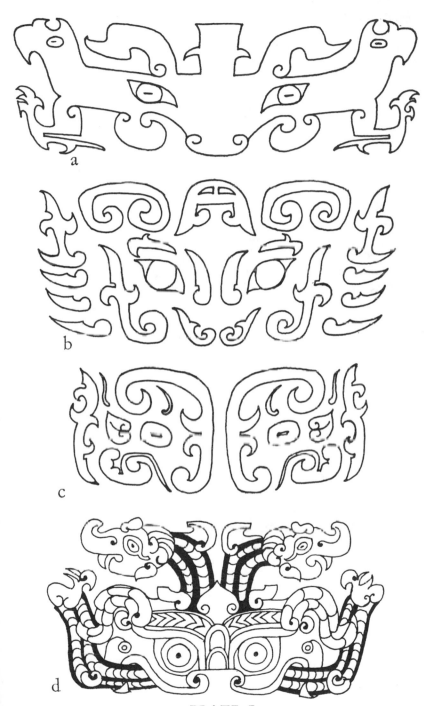

PLATE 7

in a great number of variant forms, most of which can be called feline or bovine, the remainder being indeterminate. [6*g*, *h*, 7*a*]. In practice it may occur as a full-face mask, or as two animals confronted so closely in profile as to produce an impression of a full-face mask. If it occurs as two animals, it consists fundamentally of two *k'uei* dragons seen in profile, displaying an open jaw so that fangs show in both upper and lower jaws; there is a prominent eye, well-marked eyebrow, a crest or horn, a smoothly curving decoratively drawn ear, a long body with one paw or claw, and an upswept tail. It differs from the true *k'uei* dragon mainly in the size of the head and the emphasis given to the eyes and ears. In many specimens the body is detached from the head, and in some cases the whole mask dissolves into a series of apparently unrelated parts. [7*b*, *c*]. The general expression varies from the ferocious to the benign. In Middle Chou the motive is less common, but returns to popularity in a modified form in the Huai style, where it resembles more the full-face type, though it is often rather complex. [7*d*]. In a simplified form it has remained a common decorative motive down to modern times.

Also called the Glutton Mask, following the explanation of a writer of the 4th or 3rd century B.C.

Ten Stems, cyclical signs associated in pairs with the five elements, wood, fire, earth, metal and water. The signs were originally used for naming the days, but were later combined with the Twelve Branches (q.v.) to make the 60-day cycle and the 60-year cycle. The Stems occur in bronze inscriptions and are a common feature of some of the mirrors of the Han period.

Thunder Pattern. Squared or rounded spirals forming a background filling motive is the commonest form, but tight S-curves as a decorative filler is also covered by the term. The pattern may not always be confined to the background; it also occurs on the bodies of *k'uei* dragons (q.v.) and on *t'ao-t'ieh* masks (q.v.). It is almost exclusively a Shang and Early Chou motive, but lingers on in a few Middle Chou pieces. Called *lei-wên* by the Chinese.

Tiger Tally, in two parts, which fit together by the mortising of lugs and slots. It is made in the form of a tiger, and down the

PLATE 8. BRONZES. *a-d*] Ting. *e*] To. *f*] Ting. *g*] Tou. *h*] Tui. *i*] Square Hu. *j*] Tiger Tally. *k*] Tsun. *l*] TLV Mirror.

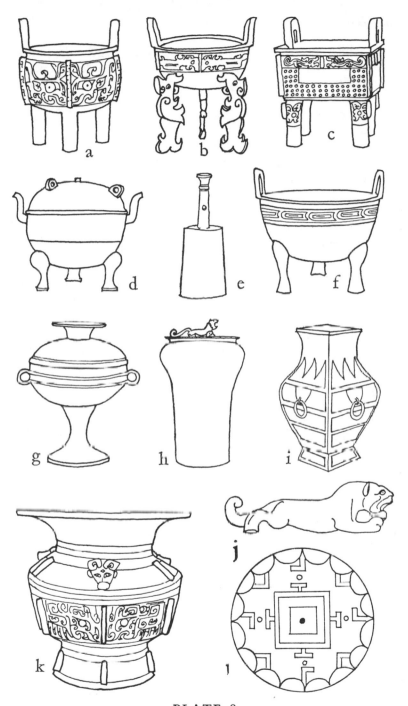

PLATE 8

spine, which forms the line of junction between the two parts, is an inscription; this can only be read when the correct halves are fitted together. Most of these tallies date from the Han period and many of them are gilt. They vary in length from 2 or 3 inches to as much as 9 inches. [8*j*].

Ting, a round vessel on three legs, or a rectangular vessel with four legs; intended to contain food. The type was produced throughout the Bronze Age, though modified in form and decoration from one stylistic period to another. The rectangular type is found only in the Shang and Early Chou periods [8*c*]; during these two periods there are some round examples with legs in the form of birds or animals standing on their tails, and supporting the vessel on the beak or snout [8*b*]; in all other cases the legs are cylindrical. [8*a*]. In the Middle Chou period the form of the leg changes to a slight S-curving type, resembling the cabriole leg, and the bowl of the vessel becomes shallower. [8*f*]. The handles do not always rise directly from the rim, but may spring from the body below and bend round and upward. In the Huai style period the vessel acquires a domed cover, sometimes ornamented with crouching animals; the legs retain their S-curve. [8*d*]. The vessel continued to be made after the end of

the Bronze Age, and under the influence of Buddhism its function changed to that of an incense burner for use in Buddhist temples.

TLV Mirrors are those mirrors in which the dominant decorative motives are elements resembling the letters T, L and V; such mirrors may be of the Cosmic type (q.v.), in which case they have the special elements that distinguish the type added. Not all TLV mirrors are inscribed, and only a few were made prior to the Han period. [8*l*].

To, a hand-bell with a clapper. The handle is either socketed for mounting on a shaft, or is long enough to be held in the hand; the latter type may be perforated for the passage of a cord, or it may have a small loop at the end for the same purpose. Introduced in the Middle Chou period and continuing through Huai. [8*e*].

Tou, a wide bowl on a high, spreading foot in its earliest form. Later the bowl gained a high and more slender stem with a splayed foot. It is common to all three stylistic periods, but only in the Huai does it appear to acquire a cover, which may be so made as to become an additional bowl when it is removed and reversed. [8*g*].

Triple Lozenge, a group of three diamond forms consisting of one large one in the centre, with a smaller one overlapping it on each side. It may be a primary or secondary element in Huai style and in the Han period, and it occurs in many other mediums beside bronze. The term was introduced by Karlgren, who originally called it 'zig-zag lozenge'. [9*i*].

Tsun, a massive wine vessel, generally with a broad body, well-shaped sloping shoulders, and a wide flaring mouth [8*k*]; the foot is of medium height and spreading. The decoration tends to be lavish with *t'ao-t'ieh* (q.v.) and *k'uei* dragons playing an important part, though bird-forms are also used. The shoulders are sometimes decorated with free-standing animal heads. In some cases the vessel has flanges (q.v.) that may come right up to the edge of the mouth, or even beyond. It does not appear in this form after the end of Early Chou, and most are of the Shang period. *See also* Animal Tsun, Bird Tsun and CERAMICS, Tsun.

Tui, a clapperless bell for suspension, oval or circular in section, and wide at the top, on which is an everted rim; the lower body tapers slightly. The top is surmounted on one side by a freely modelled animal, usually a tiger;

it is not as a rule decorated in any other way. The type is said to have been used for military purposes. Those that survive date from the Huai and Han periods. [8*h*].

Tui. A roughly spherical vessel made in two identical halves. Both base and top have three lugs or rings to stand on. Those that survive often appear to have been cast to accept inlays. Introduced during Middle Chou.

Twelve Branches, or Duodenary Cycle of symbols, used to divide up the 24 hours of the day into two-hour periods. The symbols are also equated with the Chinese signs of the Zodiac and the 12 points of the Chinese compass; they also combine with the Ten Stems (q.v.) to make up the 60-day and 60-year cycles. They occur as part of the decoration on Cosmic Mirrors (q.v.) of the Han period.

Vertical Scales, a Middle Chou decorative motive consisting of overlapping elements resembling fish scales. [9*c, d*].

Warring States, Period of the. This term in connection with bronze design and decoration is no longer current, though it may still be found in older publications. The historical period of the Warring States coincides only with the

latter part of the Huai stylistic period.

Water Patina is the name commonly given to the thin, smooth greenish or greyish patina of hard type sometimes found on Chinese bronzes. This type of patina appears to develop on pieces from dry zones with a stable climate, in which wide fluctuations of temperature and humidity do not usually occur. Although the belief is widespread that it is less vulnerable to disease than an encrusted patina, this may not in fact be true once the piece is removed to an unstable climatic situation, particularly if the 'skin' is in any way damaged. *See* PATINA.

Wavy Line, an element of Middle Chou decoration; an undulating pattern often interspersed with debased *k'uei* dragons (q.v.). [9*a*, *b*].

White Tiger. *See* ANIMALS OF THE FOUR QUARTERS.

Whorl Circle is an element in Shang and Early Chou bronze decoration consisting of a low boss with spirals curling in towards the centre, usually four or five, the centre of the boss sometimes being given added emphasis by the addition of a small circle, either intaglio, or in low relief. [9*e*, *f*].

Ya-hsing, literally Ya-shaped. The term is given to a curious device inscribed on bronzes of the Shang period. This same 'shape' occurs as the outline of the central coffin area in some of the royal tombs of the Shang Dynasty at Anyang. [9*g*].

Yen, also called *hsien*, a steamer for vegetables. The base resembles the *li* (q.v.) or the *ting* (q.v.), according to whether or not the legs are hollow. The vessel is usually made in two parts, the upper part having a grating at the base; the rim carries ear handles. If the vessel is cast in one piece, the grating between the upper and lower parts is usually hinged, It appears in all stylistic periods, some of those of the Middle Chou being rectangular, and those of the Huai style having ring handles mounted on the sides of the upper bowl, in place of the earlier ear handles. [9*h*].

Yu, a wine vessel, varying a great deal in shape from tall and slender to short and stout; almost universal characteristics are, greater width at the belly than at the neck, a swing handle and a cover. The

PLATE 9. BRONZES. *a–b*] Wavy Line. *c–d*] Vertical Scales. *e–f*] Whorl Circle. *g*] Ya-hsing. *h*] Yen. *i*] Triple Lozenge. *j*] Yu.

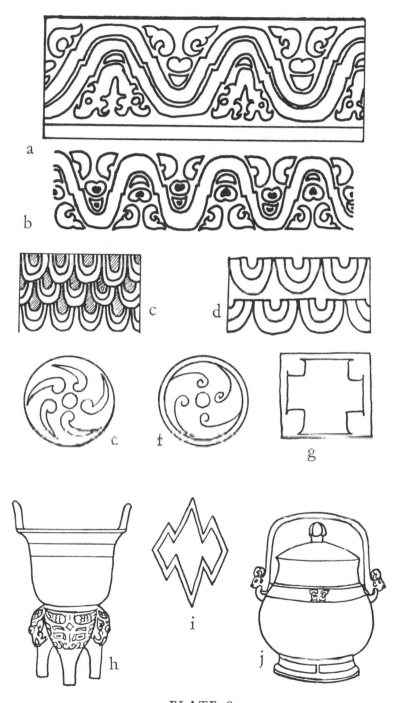

PLATE 9

foot, when not broken up into birds' feet, is up to 2 inches high and slightly spreading. The swing handles are frequently surmounted by animal heads at the point at which they connect with the lugs on the body. Produced in Shang and Early Chou; those of the latter period have a tendency towards extremes in ornate treatment of form and decoration. [9j].

Yü, a wide-mouthed wine or water vessel with a cylindrical body flaring a little at the rim, and with a splayed foot. It has two bent ear handles (q.v.). The vessel is not common, apparently occurring only in Early Chou. The body may be decorated with Hanging Blades (q.v.) of a kind more commonly found on *ku* (q.v.) or *tsun* (q.v.) and never, so far as is known on *kuei* (q.v.), with which this vessel is sometimes confused.

Yüeh. *See* AXES.

Zig-zag Lozenges. *See* TRIPLE LOZENGE.

BRONZES

RECOMMENDED BOOKS

FOSTER, K. E. *A Handbook of Ancient Chinese Bronzes.* Claremont, California, 1949.

HANSFORD, S. H. *The Seligman Collection of Oriental Art,* Vol. 1. *Chinese, Central Asian and Luristan Bronzes,* etc. London, 1957.

KARLGREN, B. *Catalogue of Chinese Bronzes in the Alfred P. Pillsbury · Collection.* Minneapolis, 1952.

KARLGREN, B., & WIRGIN, J. *Chinese Bronzes in the Nataneal Wessén Collection* Stockholm, 1969.

KARLGREN, B. *Yin and Chou Researches.* Stockholm, 1935.

KELLY, C. Γ. & CH'ÊN MÊNG-CHIA. *Chinese Bronzes in the Buckingham Collection.* Chicago, 1946.

KIDDER, J. E. *Early Chinese Bronzes in the City Art Museum of St. Louis.* St. Louis, 1956.

LODGE, J. E. & others. *A Descriptive Catalogue of Chinese Bronzes in the Freer Gallery of Art.* Washington, 1946.

LOEHR, M. *Ritual Vessels of Bronze Age China.* Asia Society, New York, 1968.

POPE, J. A. & others *The Freer Chinese Bronzes.* Washington, 1967–69. 2 vols.

WATSON, W. *Ancient Chinese Bronzes.* London, 1962. Revised edition 1977.

WHITE, C. W. *Bronze Culture of Ancient China.* Toronto, 1956.

YETTS, W. P. *The Cull Collection of Chinese Bronzes.* London, 1939.

YETTS, W. P. *The George Eumorfopoulos Collection of Chinese and Corean Bronzes,* etc. London, 1929–32. 3 vols.

BUDDHISM ☆

Buddhism, which developed in India during the 4th and 3rd centuries B.C., began to reach China in the Han Dynasty, probably during the 1st century B.C. The Chinese received the teaching of both main schools, the Mahayana and the Hinayana to which reference is made below; the Mahayana school became the most popular and the one under the influence of which, the religious art flourished most vigorously. The cave temple sites of Tun-huang, Yün-kang, Lung-mên and T'ien-lung Shan are probably the best-known monuments of sculpture from the 4th to the 9th centuries, with Tun-huang probably more famous for its paintings, than for its stucco sculpture. The great persecution of Buddhism in A.D. 844–5 dealt a blow at stone sculpture from which that art never fully recovered, although small gilt, or lacquered bronze figures, as well as wooden ones continued to be popular. In painting, and in the decoration of minor objects of the industrial arts, Buddhist themes remained popular. In the later periods, particularly in the Ming and Ch'ing dynasties, the iconography became extremely complicated and often confused, so that the identification of particular figures is frequently uncertain.

The terms and names included in the following pages are no more than a minimum basic list for those anxious to identify figures and themes. For a more detailed approach reference should be made to the books listed at the end of this section.

Abhaya Mudra. *See* MUDRA.

Amitabha, in Chinese *A-mi-t'o-p'o*, or simply *Mi-t'o*. The Buddha of Boundless Splendour, who presides over the Western Paradise. Particularly popular in Chinese Buddhism.

A-mi-t'o-p'o. *See* AMITABHA.

Ananda. One of the chief disciples of the historical Buddha, he was the master of hearing and remembering; he is said to have compiled the Sutras. He is reckoned the second patriarch. Dressed as a monk, he often appears together with Kasyapa (q.v.) in support of the Buddha.

Anjali Mudra. *See* MUDRA.

Apsaras. A heavenly being, a goddess, a term often used in European texts to refer to celestial musicians and dancers in attendance on Buddhas and Bodhisattvas.

Arhat. A worthy; an enlightened, saintly man. The highest type of saint of Hinayana Buddhism (q.v.) in contrast to the Bodhisattvas (q.v.) of Mahayana Buddhism (q.v.). They are called Lohan by the Chinese, who have arranged them in groups of 16, 18 or 500.

Asanas. A seat or throne; also mystic attitudes of the legs.

Assault of Mara. *See* LIFE OF BUDDHA.

Asura. Evil beings at war with the gods; demons. One class of supernatural being mentioned in the Lotus Sutra (q.v.), and represented as small, ugly creatures.

Avalokitesvara. In Chinese *Kuan-yin*, Lord of Compassion. A Bodhisattva (q.v.) depicted first as a man, but by the Sung Dynasty (A.D. 960-1279) is usually shown as a woman, and is known as Goddess of Mercy, usually identifiable by the ambrosia bottle (kalasa) or the lotus flower held in the hand, and the small figure of the Buddha in the diadem. In late times she may be represented with a fish basket, or holding a baby.

Bath. *See* LIFE OF BUDDHA.

Bhadrasana. Seated with both legs pendent.

Bhumisparsa Mudra. *See* MUDRA.

Bodhidharma. In Chinese *P'u-t'i-ta-mo*, or *Ta-mo*, the 28th Indian and 1st Chinese patriarch. Shown in two forms (*a*) a well-built, curly-haired man with a rosary in his hand, crossing the sea on a sword or a millet stalk; (*b*) an emaciated man crossing the sea on a millet stalk and holding

a shoe in his right hand. He was the reputed founder of Ch'an (Zen) Buddhism in China and is said to have arrived there in A.D. 520, but his existence has been questioned.

Bodhisattva. In Chinese usually referred to by the abbreviated name of *P'u-sa*. A potential Buddha, or in Mahayana Buddhism (q.v.) which was much favoured in China, one who has achieved perfect enlightenment and is entitled to enter directly into Nirvana (q.v.), but who renounces this in order first to bring salvation to all suffering mankind. Such figures appear alone, or in pairs in support of a Buddha. Unlike the Buddha, who is always a simple figure without adornment, the Bodhisattvas are crowned and loaded with jewels. The best-known figures are Avalokitesvara (q.v.), Manjusri (q.v.), Samantabhadra (q.v.), Ksitigarbha (q.v.) and Mahastamaprapta (q.v.). Before his enlightenment the historical Buddha is often referred to as 'the Bodhisattva'.

Buddha. The one who is perfectly enlightened and has entered Nirvana (q.v.). In Mahayana Buddhism (q.v.), there are many Buddhas in existence at the same time; Hinayana (q.v.) admits of only one in existence at a time. Sakyamuni Buddha, the historical

Buddha, is just one of a long line of Buddhas, with Maitreya (q.v.) still to come.

Cakra. The wheel or disc, a symbol of sovereignty, the Wheel of the Law. The Buddha by his enlightenment overcame illusion, *kharma* (the sum of past lives) and suffering. When he expounded his doctrine he demonstrated his victory by 'setting in motion the Wheel of the Law', the chariot wheel of truth and salvation. The wheel thus becomes a symbol of enlightenment, and suggests the domination of all by the Buddha's law.

Chandaka. The personal servant of Sakyamuni Buddha (q.v.) up to the time of the Great Renunciation. *See* LIFE OF BUDDHA.

Cintamani. The magic jewel; precious pearl, philosopher's stone.

Dharmacakra Mudra. *See* MUDRA.

Dhyana Mudra. *See* MUDRA.

Dhyanasana. The pose of meditation with legs crossed. Also called Paryankasana and Vajrasana (the Diamond Pose).

Dvarapala. A guardian figure. Two such figures often stand at the gate of a temple or a tomb. With bulging eyeballs and horrific grins, armed with sword and

spear, they ward off evil spirits from the sacred precincts of the Buddha Hall. They are sometimes shown stamping on the demons of ignorance and illusion.

Eleven-headed Kuan-yin. A manifestation of Avalokitesvara especially connected with Tantric Buddhism.

Enlightenment. *See* LIFE OF BUDDHA.

Farewell to Kanthaka. *See* LIFE OF BUDDHA.

First Seven Steps. *See* LIFE OF BUDDHA.

Four Encounters. *See* LIFE OF BUDDHA.

Four Guardian Kings. *See* LOKAPALA.

Gandharva. Gods of fragrance and music. One class of supernatural being mentioned in the Lotus Sutra (q.v.). Indra's musicians. They are usually shown as small celestial figures similar to apsaras (q.v.) with censers or musical instruments.

Garuda. The king of birds, a mythical being. Associated with fire and is sometimes used as a symbol of it.

Gautama. The name of the historical Buddha's family, which with the passage of time has come to mean the Buddha himself in most instances. He is frequently referred to as 'the Bodhisattva' before the enlightenment. *See* LIFE OF BUDDHA.

Great Renunciation. *See* LIFE OF BUDDHA.

Hinayana. The 'Small Vehicle' doctrine of Buddhism; much nearer to the original teaching of the Buddha than Mahayana (q.v.). Hinayana survives in Ceylon, Burma, and Siam and is more orthodox and in the direct line than Mahayana, which gives more attention to metaphysical speculation. The term Hinayana is a derogatory one coined by the Mahayanists, who held that the Hinayanist sought personal arhatship, and the destruction of body and mind and extinction in Nirvana, thus lacking the broad universalism of their own doctrine. The emphasis of Hinayana is on the doctrine rather than on the worship of the Buddha.

Jatakas. Stories of the previous lives of the Buddha in either human or animal form.

Ju-i. An elongated S-curved object; a symbol of discussion often held by Manjusri (q.v.), when debating with Vimalakirti (q.v.).

Kalasa. The rain vase, or ambrosia bottle commonly held by Avalokitesvara (q.v.).

Kasyapa. In Chinese Buddhist art he is usually accepted as the chief disciple of the Buddha, who became the elder, and first patriarch after the master's death. In Buddhist art he is shown as an elderly monk with a heavily lined face and often appears with Ananda (q.v.) in support of the Buddha, sometimes with two bodhisattvas (q.v.) as well.

Kinnara. Celestial musicians and dancers. One class of supernatural being mentioned in the Lotus Sutra (q.v.) and represented as small figures dancing with trailing scarves, or as human-headed birds with musical instruments.

Ksitigarbha. In Chinese *Ti-tsang*. The Guardian of the Earth, the Bodhisattva, who delivers from Hell. Usually shown dressed as a monk holding a pilgrim's staff (khakkara) with a rattle at the top. He may also carry on one open upturned palm the cintamani (q.v.) or jewel.

Kuan-yin. *See* AVALOKITESVARA.

Kuvera. *See* VAISRAVANA.

Lalitasana. To be seated with one leg pendent.

Life of Buddha. The major events in the life of the historical Buddha are frequently depicted and are set out in chronological order below. It is helpful to remember that the historical Buddha was a son of the Gautama family in the Sakya clan; his father was King Suddhodhana of Kapilavastu, his mother's name was Maya, and in his youth he himself was known as Prince Siddartha. For these reasons he is often known as Gautama, Sakya-muni (the Holy One of the Sakyas) and as Prince Siddartha. The main events of the Life tend to be arranged in groups of four or eight, probably corresponding in some way with the doctrine of the Four Noble Truths and the Eightfold Path. The events making up a group vary, but the Nirvana is never omitted.

Maya's Dream, or the conception; shown as a woman asleep on a couch, with a small elephant, sometimes ridden by a child coming down towards her from above, signifying the descent of the Bodhisattva from the Tusita Heaven, where he has been awaiting the time of his re-birth.

Nativity. The birth of Gautama, who is said to have sprung from his mother's side while she rested in the Lumbini Grove, is generally shown as a woman standing with one hand against a tree-trunk, while an attendant

receives the child from her side. *The Bath*, usually presided over by the Nagas (q.v.), who make a screen at the child's back. In painted examples there may be either a bath-tub, or a small fountain, or a waterfall in addition to the Nagas.

First Seven Steps, taken by the infant Gautama in the direction of each of the cardinal points to which he announced the end of birth, old age, sickness and death. Illustrated as a child pacing forward, each pace being marked by a lotus flower.

Four Encounters. The youthful Prince Siddartha secretly leaves the palace on four occasions to meet for the first time old age (a man leaning on a staff), sickness (a man propped up in bed), death (a man under a shroud), and poverty (a man shorn and shaved carrying an alms bowl).

Great Renunciation. The prince is usually shown mounted on his horse Kanthaka riding away from the city gate, the hooves of his horse being supported by apsaras (q.v.). He may be accompanied by his servant Chandaka. The fact that the 'departure from the palace took place at night is sometimes indicated by additional figures lying asleep in a pavilion.

Farewell to Kanthaka. After leaving his home at Kapilavastu, Gautama sends his horse (some-times the servant Chandaka as well) back to the city. The horse Kanthaka is shown 'kneeling' before the Bodhisattva. The interpretation in visual terms of this event seems to be peculiar to China.

Assault of Mara. The Bodhisattva is seated under the Bodhi-tree with the forces of the Evil One on either side; these are usually represented as demons in a state of fury together with the beautiful and seductive daughters of Mara. The Bodhisattva remains unmoved in meditation, or he may be shown with his right hand in the Bhumisparsa mudra (q.v.).

Enlightenment. Buddha-hood achieved, Gautama is shown in meditation under the Bodhi-tree.

Preaching the Law, or the Sermon in the Deer Park at Benares. The Buddha expounds the doctrine of salvation for the first time. This is usually shown with the Buddha seated with his hands in the dharmacakra mudra (q.v.). He may be seated on a lotus throne, or be supported by lions; there may also be a pair of deer, one at each side, symbolic of the Deer Park.

Parinirvana, 'brought to an end', the death of the Buddha. He is shown either alone, and apparently asleep, or with mourning figures around him, and with birds and animals coming towards him bearing flowers.

Lohan. *See* ARHAT.

Lokapala. The Guardian Kings of the Four Quarters, Guardians of the World and the Buddhist faith. They are usually of fearsome aspect and armed; they stand at the entrance to a Buddha Hall. The best known is Vaisravana (q.v.).

Lotus Sutra. In Sanskrit *Saddharma Pundarika Sutra*; the fundamental text of Mahayana (q.v.) and the key to much of Chinese Buddhist art. The earliest surviving translation into Chinese dates from A.D. 406. An English translation from the Sanskrit is that made by Hendrik Kern in 1884, and a partial translation from the Chinese text has been made by W. E. Soothill in 1930 under the title *The Lotus of the Wonderful Law*.

Mahastamaprapta. The Bodhisattva (q.v.) representing the Buddha-wisdom of Amitabha (q.v.). He appears on the right of Amitabha, while Avalokitesvara (q.v.) appears on the left. This particular triad is called the Three Holy Ones of the Western Region, Amitabha presiding over the Western Paradise.

Mahayana. 'The Great Vehicle' doctrine of Buddhism, which had a strong hold in China. It is a theistic Buddhism in that Mahayana asserts the existence of a series of Buddhas and Bodhisattvas and that salvation may be gained by invocations to them, so that entry into Paradise may be regarded as an immediate possibility. It asserts the unreality of the ego and of all other things, and aims at salvation for all. Mahayanists also held that merit could be gained by the dedication of images either in painting or sculpture, the merit gained offsetting the evil of one's previous lives, thus bringing release from re-birth nearer, and making entry into a transcendent, paradisic Nirvana a foregone conclusion.

Maitreya. In Chinese *Mi-lo*, the Buddha of the future.

Mandala. A magic circle divided into circles, or squares, in which are painted Buddhist divinities and symbols. The purpose is to gather spiritual powers together to promote the operation of the *dharma*, or law. A magic diagram of either a Buddhist hierarchy, or the imagined shape of the cosmos.

Manjusri. In Chinese *Wên-shu*, the Bodhisattva of Wisdom, often shown riding a lion.

Maya's Dream. *See* LIFE OF BUDDHA.

Mi-lo. *See* MAITREYA.

Mi-t'o. *See* AMITABHA.

Mudra. Mystic ritual gestures of the hands, signifying powers and special actions. The following are the most important.

Abhaya mudra. Gesture of reassurance; the hand held up, palm outward, with fingers fully extended.

Anjali mudra. Offering; the palms of the hands pressed together as in the Christian attitude of prayer.

Bhumisparsa mudra. The Buddha's earth-touching gesture. The mystic handsign of calling the earth goddess to witness his right to the seat beneath the tree of wisdom. The arm is fully extended, the hand palm downwards with the tips of the fingers just touching the earth.

Dharmacakra mudra. The mudra signifying the Preaching of the Law. The hands are together before the breast; the index finger of the left hand touches the right hand, the finger and thumb of which are joined at the tip. The gesture is sometimes called 'turning the Wheel of the Law'. *See* CAKRA.

Dhyana mudra. Meditation; the hands, palms upwards with fingers extended, lie one on top of the other in the lap.

Vara mudra. Giving or bestowing. The arm is pendent, the hand, palm outward, has the fingers fully extended.

Vitarka mudra. Discussion. The hand held up, palm outward with the index finger, or ring finger touching the thumb. This gesture may be assumed by both hands.

Nagas. Snake spirits, especially the hooded cobra, associated with water. In China they are transformed into dragons, which have a similar association.

Nativity. *See* LIFE OF BUDDHA.

Nirvana. Liberated from existence; eternal bliss. The complete extinction of individual existence, and the cessation of re-birth. Death, and in Mahayana Buddhism (q.v.), the entry into a transcendental paradise; for adherents of the cult of Amitabha (q.v.) this meant the Western Paradise.

Padmapani. The lotus bearing; a term associated with Avalokitesvara (q.v.).

Padmasana. The Lotus Throne, for the Buddha and Bodhisattvas.

Pagoda. A stupa or reliquary. A tumulus or mound for the remains of the dead, or for sacred relics or scriptures. The Chinese

pagoda, however, is nearly always an architectural monument, either single or multi-storeyed.

Parinirvana. *See* LIFE OF BUDDHA and NIRVANA.

Paryankasana. *See* DHYANASANA.

Prabhutaratna. The ancient Buddha, long in Nirvana (q.v.), who made his appearance in his stupa (q.v.) to hear Sakyamuni, the historical Buddha, expound the Lotus Sutra (q.v.). The two Buddhas may occur in art seated side by side in a setting resembling a pagoda, or Prabhutaratna may appear in a pagoda immediately above the Buddha.

Preaching the Law. *See* LIFE OF BUDDHA.

Prince Siddartha. The personal name of the historical Buddha. His other names were Sakyamuni (q.v.) and Gautama (q.v.). Before his enlightenment he is often referred to as 'the Bodhisattva'.

P'u-hsien. *See* SAMANTABHADRA.

P'u-sa. *See* BODHISATTVA.

P'u-t'i-ta-mo. See BODHIDHARMA.

Rajalilasana. The pose known as the 'royal ease', describing

Buddha and Bodhisattva figures seated with one leg pendent, and the other raised and bent at the knee, across which lies one outstretched arm.

Saddharma Pundarika Sutra. *See* LOTUS SUTRA.

Sakti. Literally 'energy'; in both Buddhism and Hinduism, *sakti* is the wife or female energy of a deity.

Sakyamuni. The Holy One of the Sakyas. A title of the historical Buddha. Sakya was the clan name, and *muni* means a saint, a sage, holy man or monk. The two names have been run together and make up what is probably the best-known name for the Buddha.

Samadhi. Tranquillity, equilibrium; a degree of dhyana (q.v.) or meditation. The deepest form of Yoga meditation.

Samantabhadra. In Chinese *P'u-hsien.* The Bodhisattva of Universal Benevolence; he is usually shown riding an elephant.

Sariputra. The chief of the disciples before whom the Lotus Sutra (q.v.) was expounded.

Sastra. Text or manual of rules of a craft such as architecture, painting or sculpture.

Simhasana. Lion throne.

Sleeping Buddha. *See* PARI-NIRVANA.

Stupa. *See* PAGODA.

Sutra. A sacred text, usually one attributed to the Buddha himself.

Ta-jih. *See* VAIROCANA.

Ta-mo. *See* BODHIDHARMA.

Ta-shih. *See* MAHASTAMA-PRAPTA.

Tantra. Mystic formulae, a term associated with the Yoga or Tantra school, which claims Samantabhadra (q.v.) as founder. The doctrine and system was introduced into China by the famous pilgrim and scholar Hsüan-tsang in A.D. 647. The system aimed at the ecstatic mystic union of the individual soul with the world soul. The Chinese branch was established in A.D. 720.

Ti-tsang. *See* KSITIGARBHA.

Urna. The luminous curl between the eyebrows of the Buddha, from which shone a ray of light illuminating all the worlds.

Ushnisha. The fleshy lump on the top of the head of a Buddha. One of the 32 marks of Buddhahood.

Vairocana. In Chinese *Ta-jih*, the Buddha of All-pervading Light, representing, according to some sects, the spiritual body of the Buddha truth.

Vaisravana. One of the Four Guardian Kings, or Lokapala (q.v.), Regent of the North and God of Wealth; may sometimes be referred to as Kuvera.

Vajra. The Thunderbolt; wielded by Vajrapani, the Great Protector and Giver of Rain, who was one of the Lokapala (q.v.). The vajra itself also occurs as a decorative motive in most mediums. The word also means a diamond, and thus hardness and indestructibility.

Vajrapani. 'The holder of the Vajra', a protector; any figure who holds this symbol, but strictly speaking one of the Four Guardian Kings, the Lokapala (q.v.).

Vajrasana. *See* DHYANASANA.

Vara Mudra. *See* MUDRA.

Vimalakirti. In Chinese *Wei-mo-chi*. Said to have been a disciple of Sakyamuni (q.v.). A man of great learning, having supernatural powers. He was visited when sick by Manjusri (q.v.) and other disciples of Sakyamuni, the occasion being marked

by a great disputation between the two men. The scene is popular in both sculpture and painting.

Vitarka Mudra. *See* MUDRA.

Yaksa. There are two forms. (*a*) Demons in the earth or air, or in the lower heavens, evil and violent. (*b*) Attendants on Vaisravana (q.v.) God of Wealth, and then symbolic of abundance. One of the classes of supernatural beings referred to in the Lotus Sutra (q.v.).

BUDDHISM

RECOMMENDED BOOKS

BUSSAGLI, M. *Central Asian Painting.* London, 1978.

CONZE, E. *Buddhism.* Oxford, Cassirer, 1953.

DAVIDSON, J. LE ROY. *The Lotus Sutra in Chinese art.* Oxford, 1954.

GETTY, A. *The Gods of Northern Buddhism.* Oxford, 1928.

JOHNSTON, SIR REGINALD. *Buddhist China.* London, 1913.

MUNSTERBERG, H. *Chinese Buddhist Bronzes.* Rutland and Tokyo, 1967.

SIRÉN, O. *Chinese Sculpture from the 4th to the 14th Century.* London, 1925. 4 vols. (1 text, 3 plates).

SOOTHILL, W. E., & HODOUS, L. *A Dictionary of Chinese Buddhist Terms.* London, 1937.

WALEY, A. *Catalogue of Paintings Recovered from Tun-huang by Sir Aurel Stein, K.C.I.E.* London, 1931.

CERAMICS ☆

Chinese ceramics are usually divided into three main groups on the basis of their body material.

1. *Pottery* varies in degree of hardness and colour; it is generally porous and always non-translucent. It is made impermeable by the application of glaze. It is fired at comparatively low temperatures, mostly between about 800 degrees Centigrade and 1,000 degrees Centigrade. One clay alone may be used, or two or more blended together, though we believe that the Chinese usually used only one clay for any one type.

2. *Porcellanous stoneware* is hard and varies in colour from black to light grey or dirty white; it is impermeable and non-translucent. It is usually glazed, the glaze used being of a different nature from that used on pottery, and the ware is fired at temperatures between about 1,150 degrees Centigrade and 1,300 degrees Centigrade. The body is artificially constituted in the sense that both ball clay and China stone are combined in their proper proportions.

3. *Porcelain* is hard, compact in texture, fine in grain, white, impermeable and translucent. It is almost invariably glazed, and is fired at temperatures from 1,150 degrees Centigrade upwards, though the Chinese are not believed to have fired at temperatures above 1,350 degrees Centigrade. The body material is composed of the white firing clay called Kao-lin, which is specially prepared, and the white China stone, known as Petuntse, and may contain other ingredients as well.

The Chinese call pottery *wa*, and the other two wares *tz'ŭ*, a word which in English we usually translate as 'porcelain', thus

making no distinction between the two wares that are high fired and resonant, and which unlike pottery are covered with a feldspathic glaze; to the Chinese the colour of the body is of little importance.

Ai-yeh. *See* ARTEMISIA LEAF.

An-hua, 'secret' or 'hidden decoration', a type of decoration that first appeared in the Yung-lo period (1403-24) on the rare 'bodiless ware' (q.v.), and is found on many wares from the 15th century onward. It takes two forms; it is either very fine engraving on the body, or it is very fine slip applied before glazing. The second type is usually called '*an-hua* slip'. So fine and delicate is it that it is only possible to see the decoration by transmitted light; it then appears like a watermark in paper.

Apple Green. A translucent emerald green enamel applied over the glaze as a 'self-colour'; in some cases it is applied over a crackled grey glaze.

Arrow Vase. A globular vase with a long cylindrical neck, at the top of which are two cylindrical lugs. The vase was used for the 'arrow game' in which arrows were thrown by competitors, who attempted to get them into the vase or through the lugs. [10a].

Artemisia Leaf, one of the Eight Precious Objects (*see* DECORATION), but often found as a mark on porcelains of the K'ang-hsi period (1662-1722), when it was invariably carried out in underglaze blue. It is often referred to in catalogues by its Chinese name, *ai-yeh.* [10k].

Baluster Vase, a vase with a cylindrical neck and trumpet mouth sometimes described as a *yen-yen* vase. Ch'ing Dynasty and later. [10c].

Batavian Ware is a trade name applied to wares of the K'ang-hsi period (1662-1722) with a glaze varying from coffee-coloured to old gold, combined with white medallions or ornamental panels, which are decorated either in underglaze blue, or in overglaze enamels. The name owes its origin to the fact that the Dutch carried great quantities of these wares, trans-shipping them at their trading station at Batavia.

Birthday Plates, the name given to a series of plates decorated in *famille verte* enamels (q.v.), with the reign mark of K'ang-hsi on the back, and four characters,

59

wan-shou wu-chiang, 'a myriad longevities without ending', each character in a separate panel on the flattened rim. The series is reputed to have been made for the sixtieth birthday of the Emperor K'ang-hsi in 1713.

Biscuit. A term applied to ceramic wares that have been fired, but not yet glazed. The temperature of this first firing varies between about 800° Centigrade and 1,300° Centigrade according to the constituents of the body and the type of glaze to be applied.

Black Ting. A rare variant of Ting (q.v.) with a similar white body but a very glossy dense black glaze, becoming very thin and pale at the rim. Known examples are mostly conical bowls about 7 inches in diameter, with a small neatly cut, unglazed footring and base showing the hard, fine paste of the body.

Blanc de Chine. *See* TÊ-HUA.

Bodiless Ware. A very fine quality thin white porcelain, first made in the Yung-lo period (1403-24); decoration, when it occurs is usually of the *an-hua* type (q.v.). *See also* EGG-SHELL.

Bottle Vase. A pear-shaped vase with contracted neck and flaring lip. As a ceramic form it probably appears first in the latter part of the T'ang Dynasty. The Chinese call this form *yü-hu-ch'un p'ing,* and this name may be found in some modern writings. [10*b*].

Bridal Bowl, a bowl decorated with two fish, either incised or in relief. Twin fish are symbolic of wedded bliss.

Brinjal Bowls, about 8 inches or less in diameter, with flared or everted rim, roughly incised with flower and leaf sprays, with yellow, green and aubergine lead silicate enamels, in various combinations, applied directly to the biscuit (q.v.).

Brown Mouth, describes the characteristic rim of the best *Kuan* ware (q.v.) in which the dark body shows through where the glaze has run thin in the firing. Not to be confused with the brown glazed rims on wares produced from about the middle of the 16th century onward.

Brush Pot, a flat-based cylindrical jar.

PLATE 10. CERAMICS. *a*] Arrow Vase. *b*] Bottle Vase. *c*] Baluster Vase. *d*] Chih-ch'ui P'ing (Mallet Vase). *e-f*] Bulb Bowls. *g*] Brush Rest. *h*] Lien Hua. *i*] Bubble Cup. *j*] Garlic Vase. *k*] Artemisia Leaf. *l*] Kuan Jar. *m*] Hill Jar. *n*] Leys Jar.

PLATE 10

Brush Rest, an ornamental stand, often made in the form of five mountains, perhaps representing the Five Sacred Mountains of China, arranged in a straight line on a rectangular base, with the highest peak in the centre and the others diminishing in size on each side. [10*g*].

Brush Washer. This is usually a small shallow bowl with straight sides, often with a flat base without a foot-ring.

Bubble Cup. A name sometimes given to small cups or bowls of about 3 or 4 inches in diameter, with high well-rounded sides turning in a little towards the top; the foot is rather small. The form is found mainly in Chün (q.v.) and Lung-ch'üan celadon (q.v.) and their later imitations. They are also named by some people 'palace bowls'. [10*i*].

Buckwheat Celadon. *See* TOBI SEIJI.

Bulb Bowl. A wide shallow bowl on three or four feet. They were made from the Sung Dynasty onwards and are commonest in Chün (q.v.), Kuang-tung (q.v.) and glazed Yi-hsing wares (q.v.), but are also known in a number of others. [10*e*, *f*].

Café-au-lait. A lustrous brown glaze, with a wide range of tones, derived from iron. It became especially popular in the 18th century.

Canton Enamels. *See* MISCELLANEOUS section, p. 125.

Cavetto. The well of a large dish.

Celadon. A term applied broadly to wares having a greyish or brownish body covered by a transparent, or opaque, olive or greyish-toned glaze. The name is derived from the name Céladon, the shepherd, in the stage version of Honoré D'Urfé's pastoral romance *L'Astrée*, who wore ribbons of a soft grey-green tone. Among the most important wares to which the term is applied are Yüeh, Northern Celadon and the wares of Lung-ch'üan, each described under the appropriate heading.

Ch'a-yeh Mo. *See* TEA DUST.

Ch'ai, a lost imperial ware of the Five Dynasties. It was reputed to be light blue and very thin, with fine crackle lines. One source states that it was made in Chêng-chou in Honan province. Many attempts have been made to identify this ware, but all have so far proved unsuccessful.

Chatter Marks are radiating ridges, varying in prominence, on

the base of a circular vessel. It is a fault in manufacture, which occurs in cutting the foot-ring, and is due to holding the foot turning tool insufficiently firmly or at the wrong angle.

Chi-an Ware was made in loose imitation of the contemporary Chien ware (q.v.) of the Sung Dynasty. It was produced at Yung-ho in the Chi-chou district of Chi-an Fu in the province of Kiangsi, and perhaps also at other kilns. The bowls are of a coarse buff stoneware, crudely made and often conical in form, with a speckled brown glaze, with blackish brown decorations, usually of bird or floral motives; these decorations tend to run a little in firing. Also produced in this district, and often given the same name, are some mottled tortoiseshell coloured bowls of similar shape. These display a double glaze technique, the brown glaze being applied first and the yellow being splashed on afterwards.

Chiang-t'ai, 'paste bodied' wares made from a fine-grained white firing clay, often miscalled 'soft paste' (q.v.). These wares occur mainly from the 18th century onward.

Chiao-t'an, 'Altar of Heaven', which in the Southern Sung period was at Tortoise Hill, near Hang-chou; it was in the vicinity of this altar that the commercial kiln producing *Kuan* wares (q.v.) was established and operated from about A.D. 1140 onward. The site of the kiln was discovered during road-making operations in 1934 and the kiln has always been known by the name Chiao-t'an. In older publications the name is often translated 'Suburban Altar' kiln.

Chicken cups, the name given to wine cups of a type first made in the Ch'êng-hua period (1465-87), the mark of which they bear, that were decorated with a cock, hen and chicks beside a peony in full bloom, together with other smaller plants, the decoration being carried out in the combination of underglaze blue and overglaze enamel called *tou-ts'ai* (q.v.). The type was imitated in the 18th century, many of the imitations also bearing the mark of the Ch'êng-hua period.

Chicken skin is the name given to irregularities in the form of small elevations in the glaze surface.

Chien Ware, a dark coarse-bodied ware, heavy in weight, with a black glaze streaked with brown or blue-black, the glaze frequently forming a thick welt just above the foot. The glaze round the rim is usually thin and of a deep brown tone, often with

the roughness of the body perceptible through it. The tea bowls are famous and became popular in Japan, where black glazed wares gained the name *Temmoku* (q.v.).

Ch'ien Mark. A ceramic mark based on the form of a copper cash coin, which is round with a square hole in the centre; it is symbolic of wealth and is one of the Eight Precious Objects. *See* DECORATION.

Chih-ch'ui P'ing. A mallet vase (q.v.). The term is also used by some authorities for what is more usually called a *rouleau* vase (q.v.). [10d]. See also *Kinuta*.

Chinese Imari. An export ware decorated in rather dark, dull underglaze blue, overglaze red enamel and gold, in imitation of somewhat similar wares made at Arita in Japan, from whence they were carried by the Dutch merchants in the late 17th and early 18th centuries, through the port of Imari on Nagasaki Bay. The decorative motives are part Japanese and part Chinese arranged in confused patterns over the whole surface.

Chinese Lowestoft. Chinese white export porcelain painted with pink roses at Canton.

Ch'ing-pai. This literally means 'bluish white'. The name is given to a white porcelain with a clear glaze, slightly tinted blue or washy green; this tinting is easily discernible where the glaze runs thick in the hollows. The body is hard and compact, and the decoration is either incised or moulded; floral designs are the most commonly found. First made in the Sung Dynasty at a large number of kilns, it was to continue well into the Ming Dynasty; it was an important export ware for the South-East Asian and Indonesian markets. Another name for this ware is *ying-ch'ing*, 'shadow blue', but the name *ch'ing-pai* is used in connection with the ware in Chinese texts as early as the 14th century and is the correct one.

Ching-tê Chên is the great ceramic centre in the province of Kiangsi in southern China at which the imperial wares were regularly produced from the beginning of the Ming Dynasty at the end of the 14th century. Long before this time the kilns had certainly been in production and it is not known how early they came into operation. The district is exceptionally rich in all the raw materials for the manufacture of porcelain, and production still continues.

Chiu-yen. The name of a kiln site in northern Chekiang, about 30 miles from Hang-chou, where Yüeh wares (q.v.) were made

from the Han Dynasty through the Six Dynasties period to the end of the 6th century.

Ch'u-chou. *See* LUNG-CH'ÜAN.

Chü-lu Hsien, a city in Chihli in north China, that was inundated in A.D. 1108, when the Yellow River changed its course. The site was excavated in the 1920's and revealed a wide range of ceramic wares, some of the finest being white porcellanous wares of strikingly robust form and quality, unlike the delicate and sophisticated imperial wares of Ting (q.v.). Most of the white pieces are stained brown and yellow as the result of prolonged burial, and tend to be rather heavy in weight for their size. The city was apparently a market for the wares produced in the locality, there is no evidence that they were made there.

Chüeh Mark. A pair of stylised rhinoceros horns, used as a ceramic mark from the 17th century onward. They are one of the Eight Precious Objects. *See* DECORATION.

Ch'ui-ch'ing. *See* POWDER BLUE.

Chün is a buff-bodied ware with a lavender glaze, in some cases flushed with crimson or purple. The ware takes its name from one of the districts, Chün-chou, where it was made in the Sung Dynasty. It was one of the imperial wares of the Sung, but continued to be made well into the Ming Dynasty. The early pieces tend on the whole to be smaller than the later ones, which include massive flowerpots, bulb bowls and jars. The earlier pieces, too, are more dependent for their beauty on form, and the colour and texture of the thick intractable glaze, than on the more brilliant flushing of later pieces. There is a green type that is rather less common and probably early in date. The ware was made at many different kilns and it is thus natural to find that the foot-ring, which is usually the most important factor in identification, varies a great deal in both form and finish.

Clair de Lune. The French term introduced by Jacquemart in the 19th century for the Chinese *yüeh-pai*, 'moon white'. Jacquemart based his term on the bluish-grey and lavender-grey wares that were being produced in the Ch'ing Dynasty. The Chinese term *yüeh-pai*, however, covers a much greater range of colour and may be applied to wares varying in colour from pure white to a pronounced lavender tone; in the 16th century it was also applied to Chün (q.v.), *Kuan* (q.v.) and celadons in which a bluish tone was apparent.

Clobbered China. Chinese underglaze blue, and occasionally red, decorated porcelains 'improved' in Europe by the addition of green, yellow, red and other enamels and gilding, often in such a way as to overlap and disfigure the Chinese designs. The practice began in the 18th century.

Compagnie des Indes. Chinese porcelains made specifically to European order, and sometimes design also, gained this name in the late 17th century, when other East India companies than the Dutch began to take a large share in the Chinese trade.

Conch Shell Mark. This is found on blue and white porcelain of the K'ang-hsi period (1662-1722); it is often referred to as the *lo* mark. It is one of the Eight Emblems of Buddhism and is thus ultimately of Indian origin. *See* DECORATION.

Coral Glaze. Iron red enamel used as a monochrome glaze.

Crab Claw Markings, a form of large irregular crackle that occurs on wares of the Sung Dynasty, particularly *Kuan* (q.v.) The name was introduced in the 18th century, a time when many imitations of the Sung imperial wares were being made.

Crackle is a phenomena caused by the unequal contraction of body and glaze during cooling in the kiln. Technically a fault, it was exploited by the Chinese from the middle of the 12th century onward for its decorative effect.

Devil's Work. Fine openwork decoration in the form of delicate trellis patterns, usually free of glaze. Bowls and cups made in this way were sometimes lined with silver for ordinary use. A development of the 17th century, although there are a few examples that may be late 16th century. Called *ling-lung* in Chinese.

Dogs of Fo, a mythical lion type of animal resembling Pekinese dogs, usually found as guardian beasts at the gates of a Buddhist temple or on either side of a Buddha statue. They are made in pairs with their heads turned to face each other. In the ceramic medium such figures are rarely more than about 12 inches (30·5 cm.) in height and are usually elaborately decorated in *famille verte*, or *famille rose* (q.v.), enamels. They also occur as a decorative motive.

Earthworm Marks, the name given to what we know as a firing fault in the glaze of Chün wares (q.v.). They are small irregular partings in the top colour of the glaze, probably due to a failure of the intractable glaze to run

completely, when the critical temperature in the firing has been reached. The marks are particularly common on the inside of bulb bowls, where there is a pronounced lavender blue line breaking the smooth overall blue-grey of the glaze.

Egg and Spinach, green, yellow and white lead silicate enamel glazes that occur together on the same piece, but not in an organised pattern. It is a type of decoration that first occurs with this name during the K'ang-hsi period (1662-1722) and is a variant of 'tiger skin' (q.v.).

Egg-shell, an extremely thin, pure white porcelain, sometimes with a ruby enamel back, when it is used for bowls. It is called t'o-t'ai, 'bodiless' (q.v.) by the Chinese.

Enamel on Biscuit. This is the application of soft lead silicate enamels to a vessel that has previously been fired without any glaze on it. This initial firing is often to the temperature required for porcelain, that is, to about 1,250 degrees Centigrade or above; after the application of the enamels the piece was fired again at a somewhat lower temperature. The technique was used for Ming fa-hua (q.v.) and Ch'ing san-ts'ai.

Fa-hua is the name given to the cloisonné-style decorated porcelain of the Ming Dynasty, in which the decorative motives are outlined with threads of slip (q.v.), or incised lines, that serve to separate the different coloured lead silicate enamels from each other, in the same way as do the copper wires in cloisonné enamel (*See* MISCELLANEOUS section, Cloisonné). This style of decoration may also be called san-ts'ai (q.v.).

Fa-lan. *See* FA-LANG.

Fa-lang. A term used primarily for enamel decoration on metal of the Canton type (*see* MISCELLANEOUS section, Canton Enamels), but which is sometimes used with reference to wares of the *famille rose* group (q.v.). Other terms that are also used somewhat loosely in the this way for enamelling on porcelain are fo-lung, fu-lang, fu-lan and fa-lan.

Famille Jaune. A group of enamel decorated porcelains of the K'ang-hsi period (1662-1722) and later, in which the predominant background colour is yellow. The group was distinguished by Jacquemart.

Famille Noire. A group of porcelains made from the K'ang-hsi period (1662-1722) onward in which the dominant background colour is black. It is really a

67

variant of *famille verte*, (q.v.), since it consists of a dull black ground covered with a green enamel. It was distinguished by Jacquemart in the 19th century.

Famille Rose is a term coined by Jacquemart in the 19th century and applies to a group of overglaze enamelled porcelains which begin about 1721. The delicate rose pink which is characteristic of the group is an opaque colour derived from colloidal gold. All the colours in the group are opaque and stand up more in relief than those of the *famille verte* translucent type (q.v.). The wider palette and more manageable qualities of these *famille rose* enamels made a more meticulous style of painting possible. By about the middle of the 18th century Western subjects became a popular novelty. This group of enamels is also known by its Chinese name *yang-ts'ai*, 'foreign colours', or *fên-ts'ai*, 'pale colours'.

Famille Verte is a term coined by Jacquemart in the 19th century and applies to a group of translucent enamelled wares on which the predominant colour is green. One colour, iron red was opaque, but this rarely plays an important part in the decoration. The use of green enamel has its origin in pieces made as early as the 13th century, but the term *famille verte* is applied only to types made from the 17th century onward, which differ much in style from earlier wares. The subjects of decoration are at first simple designs of birds and flowers; these start towards the end of the Ming dynasty at the beginning of the 17th century. By the end of the century the designs had become complex and detailed, with landscapes and genre scenes, illustrations from legends, history and romance, but they never achieved the same minute and meticulous style as the *famille rose* (q.v.), or the even finer and more delicate type known as *Ku-yüeh hsüan* (q.v.). They have nevertheless remained popular.

Fan-hung. *See* IRON RED.

Fang Shêng Mark. An open lozenge threaded with a ribbon. The mark occurs mainly in the K'ang-hsi period (1662-1722). It is one of the Eight Precious Objects. *See* DECORATION.

Fei-ts'ui, 'kingfisher colour', the name given to a bright, almost luminous turquoise-coloured glaze derived from copper; another name for it is 'peacock green'. *See also* this term under JADE AND HARDSTONES.

Fên-ting. *See* TING.

Fên-ts'ai, 'pale colours', a Chinese term for the *famille rose* porcelains (q.v.).

Fish Roe Crackle, the name given to the crackle on Ju wares (q.v.) at the time when, in the 18th century, imitations were being produced at Ching-tê Chên (q.v.).

Flambé, a copper red streaking on a smaller or larger scale on porcelains of the 18th century onward. It is a term also applied by some writers to the crimson flush on Chün wares (q.v.).

Fo-lang. *See* FA-LANG.

Fu-kuei Ch'ang-ch'un, 'riches, honour and a prolonged Spring'. A good wish mark sometimes found on the base of an object; it also occurs combined with other motives as part of a decoration. The implication of 'prolonged spring', is prolonged youth.

Fu-lang. *See* FA-LANG.

Garlic Vase, a bottle-shaped vase with a swelling at the mouth similar to a bulb of garlic, sometimes even ribbed in the same way. [10*j*].

Garniture de Cheminée, a set of five pieces for arrangement on a mantelpiece. Three pieces are covered jars, one of which is placed at each end with the third in the centre, and the other two are wide-mouthed beakers of *Ku* form (*see* BRONZES; *Ku*), which are placed between the jars.

These sets are particularly common in blue and white and in *famille verte* (q.v.); they were popular in Holland in the 17th century and were copied at Delft and other continental ceramic centres.

Gombroon. *See* RICE GRAIN.

Green Chün, an uncommon Sung ware with a thick, rich grey-green glaze, often finely crazed on a Chün (q.v.) type body and usually of similar form; a rather flat, narrow-rimmed saucer is the best-known form. The ware is related to Northern Celadon (q.v.) as well as Chün and was clearly made at the same kilns.

Hang-chou Celadon. A term, for which there is but little justification, for a type of crackled celadon that has affinities with Lung-ch'uan celadon (q.v.).

Hard Paste. Porcelain produced from the appropriate proportions of Kao-lin (q.v.) and Petuntse (q.v.) and fired to a temperature of about 1,150 degrees Centigrade or above, so as to produce vitrification and translucency.

Hare's Fur. A glaze effect that occurs on Chien (q.v.) and on some of the related black wares, in which the black glaze is finely streaked with brown or a metallic-looking purple or blue-black.

Hare Mark. A hare used as a mark in the 16th and 17th centuries.

Hawthorn Design. A misnomer for prunus decoration.

Hawthorn Vases. A name still commonly applied to large *famille noire* (q.v.) and *famille verte* (q.v.) vases decorated with prunus branches.

Hill Jar. A squat, cylindrical jar mounted on three small feet. The jar is surmounted by a more or less conical cover, moulded to resemble mountains. [10m]. Such jars usually date from the Han period (206 B.C.—A.D. 220). *See also* BRONZES.

Hsing. The name of a white porcelain produced in the T'ang Dynasty. It is named after the district of Hsing-chou in Ho-pei where it is traditionally believed to have been produced. The body in early examples is often covered in white slip (q.v.) before glazing, and the rims of bowls may be thickened.

Hsiu-nei Ssŭ, 'Palace Department of the Board of Works'. The name is traditionally associated with a kiln run by this department which is said to have been located at the foot of Phoenix Hill at Hang-chou sometime after A.D. 1128. The kiln site has never been located in spite of this tradition, nor have the wares produced at it been satisfactorily identified in spite of many attempts. The wares would seem to have been some form of *Kuan* (q.v.), or possibly celadon (q.v.). Tradition also suggests that the kiln was not an economic one during its period of production, and that the work was taken over after a time by the Chiao-t'an (q.v.) kiln, which was run on commercial lines, and which was already producing what is now called *Kuan*. It has been suggested that the distinction between the products of the two kilns was one of quality rather than kind, and that it is unlikely that the Hsiu-nei Ssŭ kiln will ever now be located.

Hua Mark. A lozenge-shaped mark with ribbons trailing from its edge; one of the Eight Precious Objects. *See* DECORATION.

Hua Shih, 'slippery stone', a white plastic clay, related to the kaolins, sometimes used instead of kaolin (q.v.) in porcellanous wares, sometimes used alone, and sometimes as a dressing on porcelain to provide a smooth painting surface. It is said to be an essential ingredient in the manufacture of 'bodiless wares'.

Huang-pan-tien, variegated yellow glaze.

Imperial Yellow, a collector's term for yellow monochrome wares produced from the Ch'ênghua period (1465-87) onward. The colour does, however, have a ritual significance, pieces of this colour being used on the altars dedicated to the Earth, Agriculture and Sericulture, etc. The yellow colour is derived from iron or antimony, the latter giving a purer and often brighter colour than iron, which usually has a slightly brownish tinge.

Iron Foot describes the appearance of the foot-ring on the best *Kuan* wares (q.v.) of the Sung Dynasty, in which the ring shows a metallic black or purple-black where the body is bare of glaze.

Iron Red, an enamel colour derived from an iron sulphate; it is also called 'coral red', *rouge de fer*, and, by the Chinese *fan-hung*. The colour is used either as a self colour (q.v.) or in combination with other enamel colours. Like all enamel colours it is fired in a muffle kiln.

Iron Rust Glaze. A dark brown to black glaze with a fine metallic speckling produced in the 18th century.

Jardinière. The name is applied rather loosely to almost any large jar that can be used as a flowerpot, or as a cover for such an object.

Jesuit China. This is a term for which there is no foundation in fact, but which originated in the belief that this ware, decorated with Western designs, was produced under the influence of the Jesuit missionaries. The earliest wares of this kind were produced in the K'ang-hsi (1662-1722) period and were blue and white, apparently executed at Ching-tê Chên (q.v.); the later wares of the type, mostly plates and saucers, were copied from engravings of biblical or classical scenes, in black or sepia enamels with touches of gold; a few polychrome-enamelled examples are also known. Most of these last date from the Ch'ienlung period, though a few may be earlier.

Ju is an imperial ware of the Sung Dynasty, that takes its name from the district in Honan where it was first developed; the kiln site has not yet been firmly identified. The ware is generally believed to have been made for the Northern Sung court only from A.D. 1107 to 1127, the latter date coinciding with the enforced withdrawal of the court to Hang-chou in the south, as the result of the Chin Tartar invasion from the north. The date A.D. 1107 is dependent on the authenticity of a test ring bearing an inscription with that date now in the Percival David Foundation of Chinese Art in London. The ware has a very

71

fine closely-knit greyish or buff body, with a thick opaque blue-grey glaze, that has a small regular crackle. Most pieces, which were not as a rule large, were fired on three or five spurs of a whitish fireclay, the marks always remaining visible on the glazed base; these marks are called by the Chinese 'sesamum seeds'. Almost never decorated, it is especially valued for the exquisite form, glaze texture and colour. It is one of the rarest and most costly wares that survive.

Juan-ts'ai, 'soft colours', a Chinese term for *famille rose* (q.v.).

Kaki. A Japanese word meaning 'persimmon', and by extension 'persimmon coloured' when used with reference to a rusty brown glaze colour.

Kao-lin, a white firing, plastic china clay first discovered and used by the Chinese potters. Compounded of silica (50 per cent), alumina (30 per cent), potassium (2·5 per cent), approximations only, the rest being made up of iron oxides, manganese oxide, lime, magnesium and sodium, as well as water, which is lost in firing. The proportions of the constituents especially those of iron oxide, manganese oxide and sodium vary from one source to another. Kao-lin is an essential ingredient, when compounded with Petuntse (q.v.) in the manufacture of porcelain.

Kian Ware. *See* CHI-AN WARE.

Kiln Glost. The fortuitous appearance of glaze round the shoulders of a vessel, that is otherwise of an unglazed type. It is usually due to an accidental fall of ash in the kiln during the firing.

Kinuta. The Japanese name for a mallet vase (q.v.) [10*d*]. The term has also come to mean a fine quality bluish toned celadon glaze (q.v.), and reference is nowadays not uncommonly made to celadons with 'kinuta glaze'. This usage is wholly without justification.

Ko. A term which has led to much confusion and is now ceasing to be current. In older books it refers mainly to a pale brownish-grey glazed *Kuan* (q.v.) ware, with a close crackle, but may also be found with reference to a variety of the Lung-ch'üan celadon (q.v.).

Kraak Porcelain. The name given to a type of blue and white porcelain produced in the Wan-li period (1573-1619) and throughout the greater part of the 17th century. The decoration is laid out in panels and may be of one design repeating all round, or of two or three designs which alternate. The ware varies a great deal in quality of body, glaze and

colour. The name derives from the Dutch name for a Portuguese ship called a 'carrack', one of which was captured in 1603 while carrying a rich cargo that included this type of ware. The Kraak porcelain was the first Chinese ware to reach Europe in any quantity and it had a profound influence on the history of European ceramics. The designs were quickly copied by the potters of Delft and then at many other centres in Europe.

Ku-yüeh Hsüan is the name of a singularly fine type of polychrome enamelled glass-ware produced in the 18th century. The name was extended to porcelain objects decorated in the same style. The subjects executed on porcelain are generally floral, and the mark on the base is usually that of the reign period, the subjects on the opaque milkytoned glass are more varied and the mark 'Ku-yüeh hsüan' in red enamel may occur instead of the reign mark, which is either incised or enamelled in blue. It is a rare and highly esteemed ware that achieved the height of perfection between about 1727 and 1754; its production is said to have ceased after 1754. Most pieces are small.

Kua-p'i Lü, 'cucumber green', a brilliant green glaze introduced in the Yung-chêng period (1723-35).

Kuan Jar. A massive wine jar with high shoulders and a rather wide mouth. Mostly 14th century and early Ming. [10*l*].

Kuan Ware. Imperial ware of the Southern Sung Dynasty, but which continued to be made after the end of that dynasty. A generally dark-bodied ware with a thick, opaque glaze, which was applied in several layers, and which has a wider or narrower crackle. The colour of the glaze varies from a brownish-grey through grey to a delicate lavender-blue; the width of the crackle is also variable, but the more blue toned pieces tend to have a wider crackle than brownish-grey pieces, which used to be called *Ko* ware (q.v.). This term *Ko* in connection with closely crackled ware of the Sung and later periods is now obsolete. Imitations of *Kuan* ware were made in considerable numbers in the 18th century.

Kuang-tung Ware, a strong type of brown-bodied stoneware with a thick blue-toned glaze, often streaked and mottled with greyish-green, white or brown, from kilns in the vicinity of Canton. Other products of the kilns include imitations of Chün (q.v.) and Yi-hsing glazed wares (q.v.) and pieces with *flambé* effects (q.v.).

Kundika. A water vase of Indian

73

origin associated with Buddhist ritual, and introduced into the Chinese repertory of forms along with the religion. It is a long-necked vase with a long tapering spout that rises from what would normally be a flared lip; the vase is filled by way of another small spout on the shoulder. [11*a*].

Lang Yao, a brilliant blood-red glazed ware first produced in the early years of the K'ang-hsi period (1662-1722). It is better known in Europe by the name *sang-de-bœuf*. The colouring agent is a copper oxide and the glaze is usually rather thick and may be crackled. The red is rarely uniform, showing on the best pieces a variable depth of tone. The bases of Lang-yao are of three types, plain white, a greyish celadon tone with a crackle, or apple green with a crackle.

Lead Glaze. A glaze material, containing silica in the form of sand or quartz, fused by means of an oxide of lead. It fires at a low temperature (about 800 degrees Centigrade), and may be used on pottery, but not on porcelain, unless this material has first been fired without glaze to the usual high temperature required for this

material, which is approximately 1,200 or 1,250 degrees Centigrade.

Leys Jar. A vase with a widely flaring lip, probably occurring first in the 15th century. Common in blue and white, and green and yellow wares, and occasionally in Chün (q.v.). [10*n*].

Li-shui. A city, between Ch'u-chou and the sea in the province of Chekiang, which gives its name to a type of celadon that is directly descended from Yüeh (q.v.), having, it is believed, close affinities with Northern Celadon (q.v.) in the early stages, and with Lung-ch'üan (q.v.) in the later stages. It is thought to have been produced first in the late T'ang period.

Lien Hua, 'lotus flower'; a mark of the 17th century. [10*h*]. It is also a decorative motive, either on its own or as one of the Eight Emblems of Buddhism. *See* DECORATION.

Ling-chih. The sacred fungus, symbolic of longevity, is used as a mark from the late Ming period onward. It also occurs very commonly as a decorative motive, especially in association with Taoist subjects. The fungus itself

PLATE 11. CERAMICS. *a*] Kundika. *b*] Mei-hua P'an. *c*] Mei-p'ing. *d*] Narcissus Bowl. *e-f*] Pilgrim Flasks. *g*] Monk's Cap Jug. *h*] Sunflower Bowl. *i*] Ya-shou Pei. *j*] Rouleau Vase. *k*] Truncated Vase. *l*] Ting mark.

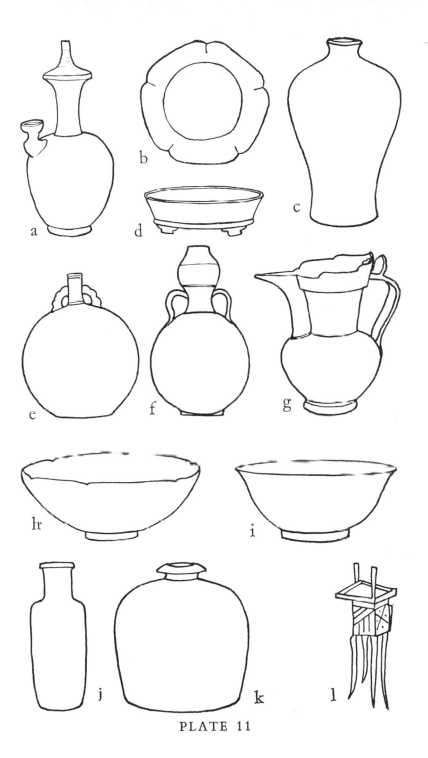

PLATE 11

has been identified as *Polyporus lucidus*.

Ling-lung. *See* DEVIL'S WORK.

Lo Mark. A conch shell mark, used mainly in the K'ang-hsi period (1662-1722). One of the Eight Emblems of Buddhism. *See* DECORATION.

Loaf Centre. A convex elevation in the centre of a bowl. The Chinese term is *man-t'ou hsin*.

Lung-ch'üan, a southern type celadon made from the Sung Dynasty onward and widely exported throughout the East. The body varies from grey to almost white, and tends to burn brick red where exposed in the firing. The glaze is thick, usually opaque and grey-green to grey-blue in colour. Decoration is either in the form of moulded reliefs luted on to the body, or, in later pieces, carved. Made at a great number of kilns in Chekiang, including those at Ch'u-chou, the name Lung-ch'üan is a type name rather than that of the precise place where it is manufactured. *See also* YÜEH, LI-SHUI and NORTHERN CELADON.

Lute. To lute, one piece to another, is the term used for joining two or more parts of a vessel together, or for sticking a decorative relief on to the surface of an object. While the two surfaces to be joined are still damp they are brought together and held in place by the use of a small amount of clay of creamy consistency, usually called slip (q.v.).

Mallet Vase, or 'paper beater', a cylindrical bodied vase, with flattened shoulders, narrow cylindrical neck on which there may be two fish or dragon-form handles; examples with handles have a flattened spreading lip. It is to this form that the Japanese term *Kinuta* (q.v.) strictly applies. It is a popular form in Lung-ch'üan celadons (q.v.). [10*d*].

Man-t'ou Hsin. *See* LOAF CENTRE.

Mandarin Porcelain. A term now obsolete. The ware is a variant of *famille rose* (q.v.) made from the latter half of the 18th century onward.

Marbled Wares. Wares made from clays of two, or occasionally more, colours, kneaded together in various ways and usually glazed with a soft transparent glaze so that the different colours of the body show through, sometimes in definite patterns. These wares were made from the T'ang Dynasty onward; they occur in a modified form in some of the Yi-hsing wares (q.v.).

Mazarine Blue. A term loosely used with reference to blue monochrome, which should be understood to mean a dark blue rather than the lighter and powder blues (q.v.).

Mei-hua P'an. 'Prunus blossom dish' with five rounded lobes. [11*b*].

Mei Kuei. Rose; sometimes meaning a rose-coloured enamel.

Mei-p'ing. 'Plum blossom vase', a vase with small mouth, wide shoulders and tall body tapering smoothly to the base. The form makes its appearance in about the 10th century or a little earlier, and has remained popular ever since. [11*c*].

Mi-sê. A glaze the colour of straw, or millet yellow, sometimes with a light brownish tone.

Mirror Black. A brilliant black glaze produced from a combination of iron and manganese oxides. An innovation of the K'ang-hsi period (1662-1722), and called by the Chinese *wu-chin*, 'black bronze'.

Mo Hung. Iron-red enamel used over the whole surface of a vessel as a monochrome effect.

Mohammadan Blue. Cobalt ores from foreign sources, which contain arsenic, unlike the native Chinese ores in which this impurity is replaced by manganese.

Monk's Cap Jug. Jugs made with a lip and cover, which in profile closely resemble the caps worn by Buddhist monks in winter. The earliest examples date from the first half of the 15th century and are known in white, copper-red, and blue and white examples. [11*g*].

Nanking China, an obsolete name for blue and white porcelain, especially of the K'ang-hsi period (1662-1722). The wares were shipped down river from Ching-tê Chên (q.v.) in Kiangsi and trans-shipped for the East India Company trade at Nanking. Equally obsolete is the term Old Nanking.

Narcissus Bowl. A shallow bowl, on four low 'cloud feet', roughly elliptical in horizontal section. [11*d*].

Nien Hao. *See* REIGN MARKS.

Northern Celadon. A grey or brownish-bodied ware, owing much to Yüeh (q.v.) for its inspiration, which has a transparent olive-brown or grey glaze; the precise tone of the glaze is dependent on the colour of the body and the degree of reduction in firing (*see* REDUCING CONDITIONS). The ware does not

appear to date earlier than the Sung Dynasty, and seems to have been made at a large number of kilns in North China; it is related in the style of its carved decoration to Ting (q.v.) and in body and firing technique to Chün (q.v.); it may indeed have been made at some of the same kilns as Chün. The ware can be difficult to distinguish from some of the Chekiang celadons, such as those from Li-shui (q.v.), that may also have a transparent glaze of similar tones. These wares do not seem to have been exported and they apparently died out sometime during the Sung Dynasty, probably after 1127 when the capital was moved south to Hang-chou.

Northern Kuan. A term used in Chinese texts on ceramics, but not so far satisfactorily explained. It refers to imperial wares of the Northern Sung Dynasty, but which of the wares are to be included in the term is uncertain. The following possibilities have to be considered; (1) Ju ware (q.v.), (2) Ju and fine quality Chün (q.v.), and perhaps Tung (q.v.); (3) Tung, or some other ware deriving from it.

Oil-spot. A silvery spotting on a black glaze, derived from iron, and caused by excesses of the metallic compound being deposited on the surface in the course of the oxidizing firing. The

effect, which is a decorative innovation of the Sung Dynasty, occurs first in the black wares of Honan; it is much admired by the Japanese Tea Masters.

Orange Peel. This is a glaze effect in which there are slight undulations and pittings in the surface; the effect occurs particularly on porcelains of the early 15th century, but may be found at any period.

Oxidizing Conditions. These conditions are achieved by allowing as much air as possible to enter the kiln during firing; under these conditions glazes containing iron oxides become yellow, brown or black. *See also* REDUCING CONDITIONS.

Pai-ting. *See* TING.

Pai-tun-tzŭ. *See* PETUNTSE.

Palace Bowl. A small bowl with curving sides and slightly flared rim. A Peking dealer's term for this type produced from the Ch'êng-hua period onward.

Palm Eyes. Small irregularly occurring pits in the surface of the glaze. Called *tsung-yen* by the Chinese, and sometimes 'pinholes' in English.

Pan T'o T'ai. Semi-bodiless.

Pao-yüeh P'ing. A full-moon shaped flask. [11e]. *See* PILGRIM FLASK.

Paper Beater. *See* MALLET VASE.

Peach Bloom is the name for a reduced copper glaze effect developed in the K'ang-hsi period (1662-1722). Pieces, usually small, were so fired as to produce a soft pinkish-red colour, shading off to green in places. The effect was an expensive one to produce successfully, and all the best pieces are of the K'ang-hsi period. The superintendent Ts'ang Ying-hsüan is generally credited with this innovation. The effect is called *p'in-kuo hung*, 'apple red', by the Chinese.

Peacock Green. A vivid, medium-fired glaze derived from copper. It was first used in the 14th century, but achieved its greatest perfection in the Ch'ing Dynasty, when it gained this name.

Peking Bowls. A name given to a type of bowl first acquired by Western collectors in Peking, but not made there. The bowls are usually plain white inside and decorated outside with opaque green, yellow, blue, dull crimson or other monochrome grounds, which are engraved with complex linear scroll work patterns, the monotony of the surface often being broken by four white medallions painted in *famille rose* enamels (q.v.) with flowers, landscapes or mythological scenes. They date from the Ch'ien-lung period (1736-95) onward, the best examples being of this and the Tao-kuang (1821-50) period. Vases and other objects may also be decorated in this way.

Petuntse. Prepared white China stone, the feldspathic non-plastic, vitrifying ingredient essential for the manufacture of white porcelain and of the glazes used for this type of ware. The name as it stands is an old romanisation for the Chinese name *pai-tun-tzŭ*, 'white briquettes', the form in which the material was sold to the potteries.

Phoenix Hill is traditionally accepted as the location for the site of the imperial kiln of the Southern Sung Dynasty, which was established by the Hsiu-nei Ssŭ (q.v.) in the vicinity of the palace at Hang-chou after 1128. Although the hill has been identified, the kiln site has not been found.

Pi-sê, 'reserved', 'secret' or 'forbidden colour', the name given to the beautiful silvery-olive glaze developed for Yüeh wares (q.v.) at Shang-lin Hu (q.v.) in the 10th century and generally held to have

been used only for the articles destined for the use of the princes of Yüeh.

Pi-t'ung. *See* BRUSH POT.

Pilgrim Flasks are of two kinds. The first is of roughly made, usually moulded, pottery or stoneware, with relief decoration under an olive-brown or green glaze, the designs often being distinctively Hellenistic or Sassanian Persian in style; the handles are small loops on the shoulder. This type dates from the late 6th century into the T'ang Dynasty. The second type are of porcelain, with underglaze blue or polychrome enamel decoration and date from the 15th century onward. [11e, f]. Both types have a flattened globular body with a shorter or longer neck; the earlier type has a solid splayed foot, the later type generally lacking this feature. The later type are called 'precious moon vases' by the Chinese.

Pin-holes. *See* PALM EYES.

P'in-kuo Hung. *See* PEACH BLOOM.

Powder Blue, cobalt blue blown on to the raw body through a bamboo tube closed at the end with fine gauze; the piece was then glazed. The technique was introduced in the T'ien-ch'i period (1621-7), but only fully developed in the K'ang-hsi period (1662-1722). Pieces may be plain blue, or have added gilt decoration, or have white panels reserved in the surface which have overglaze enamel decoration. Also called *soufflé* blue.

Proto-Porcelain, a term applied to the earliest known Chinese wares with a feldspathic glaze, for which a high firing temperature is needed. The earliest wares to which the name applies date from the 3rd century B.C., but earlier examples may well exist. The body is fine-grained, hard and of a variable grey tone, showing a tendency to burn red where exposed in the firing. Yüeh wares (q.v.) are the best-known wares of this type.

Purple Ting. A variant of Ting (q.v.) that has never been satisfactorily identified, but which may be assumed to have a similar white body and a very dark brownish glaze.

Red Ting. A variant of Ting (q.v.) with the same white body but with a rusty brown glaze.

Reducing Conditions. These are conditions produced by cutting down the air supply to the kiln during firing to such an extent that carbon dioxide is reduced to carbon monoxide, compelling the fire to absorb

oxygen for combustion purposes from the constituents of the glaze. This process accounts for the blues, greens, greys and lavender tones of Sung wares and copper-reds of the 14th century onward. *See also* OXIDIZING CONDITIONS.

Reign Marks, or *nien hao*, are inscriptions, generally in under-glaze blue, but also in overglaze red or blue enamel, consisting of four or six characters giving the title of the regnal period during which the piece is purported to have been made. Marks do not normally occur before the 15th century and should always be regarded with reserve.

Rice Grain, pierced designs on 18th-century and later porcelains, in which the glaze has filled the openings; the name derives from the size and shape of the holes. The technique is believed to have been copied from Persian wares of a similar kind, which date back to the 12th century, and were known as 'Gombroon' wares, a name sometimes found in older publications to describe Chinese examples.

Robin's Egg Glaze is a speckled opaque turquoise and blue glaze, developed in the 18th century, probably in the Yung-chêng period (1723-35). It is a bi-colour glazing technique, the blue glaze being applied as a simple all-over coat and the turquoise being blown on through gauze to produce a delicate stipple effect.

Rouge de Fer. Iron-red enamelling over a porcelain glaze.

Rouleau Vase is a vase with cylindrical body, short rather flat shoulders, a short thick neck, also cylindrical, and a slightly spreading mouth, which sometimes turns up a little at the rim. The term applies to a type of vase produced from the late 17th century onward. [11j].

Ruby Back. Egg-shell porcelain bowls, saucers and dishes, decorated inside with *famille rose* enamels (q.v.) and on the back with a uniform rose enamel varying from pale rose to a deep dull crimson. Such wares were often for export and date mainly from the Yung-chêng period (1723-35) onward.

Saggar. A fireclay box or case in which ceramic wares are placed for firing in the kiln. It protects the ware from uneven firing, and from sudden falls of ash which may foul the glaze or cause an undesired change in colour.

San-ts'ai, literally 'three colours'. A name given to certain lead silicate glazing techniques. The term is used for two types of ware; the first is the polychrome

pottery of the T'ang Dynasty, the common colours being, blue, green, yellow and a deep amber. The second type of ware to which the name is applied is lead silicate enamel-glazed porcelains of the Ming Dynasty, the more common name for which is *fa-hua* (q.v.). The porcelain is fired first without glaze to a porcelain temperature; it is then decorated with the enamel colours and fired again at a much lower temperature, the colours being separated from each other either by incised lines or by small, carefully applied threads of slip (q.v.). The colours used include, blue, turquoise, green, yellow, aubergine purple and a neutral glaze which serves as white. In both the T'ang Dynasty type and that of the Ming Dynasty the name should be regarded as referring to a technique, as the number of colours used, varies from two to six.

Sang de Bœuf. A deep rich red-coloured glaze, deriving its colour from copper, fired under reducing conditions (q.v.), and which becomes especially popular at the end of the 17th century. *See also* LANG-YAO.

Sa-po-ni. *See* SU-MA-LI BLUE.

Seal Mark. A reign mark, generally in underglaze blue, but sometimes in red or blue enamel, written in an archaic manner similar to that used on a man's personal seal, which was usually rectangular.

Seal Script. Chinese characters written in an archaic style, often used for poetic inscriptions and sometimes for reign marks (q.v.).

Self-colour. Monochrome.

Sêng-mao Hu. *See* MONK'S CAP JUG.

Sesamum Seeds. The small almost white spur marks (q.v.), usually three or five in number, resembling sesamum seeds found on the base of Ju wares (q.v.).

Shang-lin Hu. A kiln centre in Northern Chekiang about 45 miles east of Shao-hsing in Yü-yao Hsien and about 15 miles north of Yü-yao itself. It was a centre at which Yüeh (q.v.) was produced over a long period, the peak of the kiln's activity being reached in the T'ang period and through most of the 10th century. Some of the *pi-sê* (q.v.) wares were produced here.

Shao-hsing is the modern name for the old administrative city of Yüeh-chou in Northern Chekiang, in the region of which the finest Yüeh ware (q.v.) was produced.

Shên-tê T'ang Tsao, 'Made for the Hall for the Cultivation of

Virtue'. A mark used at the beginning of the 19th century on some of the enamelled porcelains.

Shu-fu, 'Imperial Palace', the characters used to mark the imperial white porcelain of the Yüan Dynasty. The two characters are usually to be found facing each other across the inside of a bowl, either incised, or more commonly in low relief under the slightly opaque glaze.

Shu Mark. Two books with a ribbon used as a mark in the late 17th century. One of the Eight Precious Objects. *See* DECORATION.

Slip, a white firing clay diluted to a thick creamy consistency and used as a surface dressing, for white-painted or trailed decoration, and luting (q.v.) of parts or clay reliefs to the body of a vessel.

Soft Chün is the name given to a ware, the body of which varies from a brownish grey stoneware to a soft pinkish brown earthenware, covered with a semi-translucent glaze, which in its turn varies in colour, from a pale grey-blue to a bright luminous turquoise blue; sometimes the glaze is splashed with crimson or purple and it is often finely crazed. It was probably made at a number of different kilns and pieces may date from the Sung

period or later; comparatively little is known of the history of this ware, possibly because it appears not to have gained imperial favour.

Spur Marks. Small circular or elliptical marks of rough whitish or blackish clay on the glaze, usually on the base, but sometimes inside a vessel; they occur in regular patterns. They are caused by breaking away the fireclay spurred stands on which an object is fired. The spurs prevent the piece sticking to the floor of the saggar (q.v.) in the event of the glaze running down and covering the foot-ring.

Stilt Marks. *See* SPUR MARKS.

Suburban Altar. *See* CHIAO-T'AN.

Su-ma-li Blue. Cobalt blue from foreign sources and traditionally believed to have come by way of Sumatra, of which name Su-ma-li is a Chinese transcription. Cobalt ores also came into China by way of Central Asia. Cobalt blue may also be found referred to by the following names; *Su-po-ni, su-ni-po, su-ma-ni* and *hui-hui-ch'ing* or *hui-ch'ing,* and occasionally *sa-po-ni.*

Su-ma-ni. *See* SU-MA-LI BLUE.

Sunflower Bowls. Round bowls with a five-lobed rim, usually of *Kuan* ware, known to the Chinese as mallow flower bowls. [11*h*].

Su-ni-po. *See* SU-MA-LI BLUE.

Su-po-ni. *See* SU-MA-LI BLUE.

Swatow Wares. The name of an attractive and robust ware from Fukien, boldly decorated in red, turquoise and black enamels. Other types include slip-decorated wares with pale blue or celadon type glazes. The pieces are commonly of large size and are roughly finished, with much sand and grit adhering to the glazed base. They were exported to Japan, South-East Asia, Indonesia and India in the 16th and 17th centuries. The name comes from one of the ports through which the ware passed out of China.

Tê-ch'ing. A group of kiln sites about 25 miles north of Hang-chou, where Yüeh wares (q.v.) were made in the Han and Six Dynasties periods.

Tê-hua. A superlatively fine white porcelain with clear glaze produced at Tê-hua in the province of Fukien. It varies in tone from a cold almost grey-white to a warm creamy colour. Although bowls, dishes and vases were produced, it is the figures, es-

pecially of Kuan-yin, Goddess of Mercy, that are best known in the West. The production of this ware began in the latter part of the Ming Dynasty, perhaps sometime in the 16th century, and has continued into modern times. It is one of the most difficult of all Chinese wares to date, owing to the long persistence of a single style of representation of figures, and the small range of forms. An alternative name for the ware, introduced in France in the 19th century, is *Blanc de Chine*.

Tea Dust. A bi-colour glazing technique in which green enamel is blown through a fine gauze on to a yellowish-brown or bronze-coloured glaze ground. The effect when fired is of a soft greenish-brown tone. It is generally regarded as an innovation of the Yung-chêng period (1723-35), although the technique was known perhaps as early as the T'ang Dynasty.

Tear Marks. Streaks and globules of glaze on the backs of bowls, dishes and plates of Ting ware (q.v.), where the glaze has run down from the rim towards the foot.

Temmoku is the Japanese reading of the Chinese name T'ien-mu, first used by the Japanese to identify the black wares better known as Chien (q.v.). The use

of this name has gradually been extended to include all black wares produced during, and perhaps immediately following, the Sung Dynasty. The name is singularly inappropriate since T'ien-mu Shan is a pair of mountains to the west of Hang-chou, nowhere near where any of these black wares were made. Its use by the Japanese has been explained by the fact that in the T'ien-mu mountains there is a Buddhist monastery to which Japanese monks came to study Zen Buddhism, and the monks returning to Japan took with them their black bowls, which they had had for daily use. There is thus no real justification for the term temmoku and the use of the specific name of the ware in each case is to be preferred.

Tiger Skin. A late 17th-century development in which enamel glazes were used direct on the biscuit (q.v.) without following a strict pattern, being spotted on in fairly large areas. The colours include yellow, green, aubergine and a neutral shade that does service for white.

Ting. A thin white porcelain, with transparent ivory-toned glaze, made from sometime in the second half of the 10th century through the Sung and Yüan Dynasties and perhaps even later. The name derives from Ting-chou

in North China, where it was first produced. The decoration, usually of floral motives, but also of birds and dragons, is either carved into the body before glazing, or moulded; in what seem to be late pieces children may appear in the designs. Bowls, saucers and dishes were usually fired upside down on the rim, which was left bare of glaze and afterwards bound with copper. The reason for this method of firing was, probably, to reduce the tendency of this ware to warp in the kiln. One peculiarity of the glaze is that it runs down from the rim towards the foot in small streaks and globules, to which the name 'tear marks' has been given. Other types of this ware are Black Ting, Purple Ting and Red Ting; different qualities of the white type are distinguished as *pai-ting* 'white Ting', *fên-ting* 'powder Ting' or 'soft Ting' and *t'u-ting*, 'earthy Ting'. The differences between *fên-ting* and *t'u-ting* are very uncertain, never having been adequately defined, but both are easily distinguishable from *pai-ting*, the finest quality, which was also the earliest of the classic imperial wares of the Sung Dynasty. The type is said to have been replaced in imperial favour after A.D. 1107 by Ju (q.v.) but there is no absolute proof of this.

Ting Mark. A drawing of the archaic bronze cauldron of this

name (*see* BRONZES, Ting) used as a mark in the K'ang-hsi period (1662-1722) and perhaps later. [11*l*]. One of the Hundred Antiquities (*see* DECORATION).

Tobi-seiji, literally 'flying celadon', the Japanese name for the rare, brown-spotted Lung-ch'üan type celadon (q.v.) so much prized in Japan. It has been wrongly called 'Buckwheat celadon'.

Tortoise Hill. *See* CHIAO-T'AN.

Tortoise-shell Bowls. *See* CHIAN WARE.

Tou-ts'ai, 'opposed colours', or 'contrasted colours', a term for porcelains of the Ming and Ch'ing Dynasties decorated in a particularly refined and delicate style, with an underglaze blue outline to the main parts of the design filled in with overglaze translucent enamels, the latter having a fairly wide range of colours and tones. Nearly all the pieces so decorated are small and seem first to have been made in the Ch'êng-hua period (1465-87).

Transitional Ware, a name given to a distinctive type of ware, mainly decorated in blue and white, that was produced between about 1580 and 1680. The wares are generally of fine quality with a good tone of blue 86

and have freely composed and drawn designs. Much of the ware was for export and some pieces carry date marks and inscriptions that make it clear that they were not primarily intended for imperial use.

Truncated Vase. A vase that resembles only the upper half of the *mei-p'ing* type (q.v.). It occurs only in Tz'ŭ-chou types and black wares, believed to come from Honan, which are also of Tz'ŭ-chou type. [11*k*].

Tsung-yen. *See* PALM EYES.

T'u-ting. *See* TING.

Tung Ware. A rare Northern Sung ware, that has been tentatively identified with a celadon type of which only about half a dozen pieces are recorded. The body is a rather pale grey buff, sometimes with carved decoration, details being lightly incised, under an opaque soft grey-green glaze of unusually fine texture; the pieces are remarkably light for their size. It is said to have been made at the *Tung* kiln, 'Eastern' kiln outside K'ai-fêng, the capital of Northern Sung in Honan, but the region has been inundated so many times by the Yellow River that no kiln site has yet been located. The ware is closely related to Northern Celadon (q.v.), Chün (q.v.) and Ju (q.v.).

Tz'ŭ-chou. The name given to a strong stoneware first made in the Northern Sung Dynasty. Although made in the Tz'ŭ-chou district in modern Hopei in North China, it was produced at many kilns in other parts of China; the name should therefore be regarded as a type name rather than that of a specific kiln product. The most common forms are ewers, vases of *mei-p'ing* form (q.v.) and bottle vases (q.v.), jars, deep bowls, and headrests; one special form is the truncated vase (q.v.). The pale grey body was usually covered in white slip (q.v.) to provide a suitable surface for decoration, which was either of boldly painted floral motives in dark brown, or black under a clear or slightly creamy glaze, or it was cut through the slip in *sgraffito* technique to the body underneath, so that when glazed and fired the design would show up dark against the white ground. From the Yüan period onward it was not uncommon to cover the whole body with a dark brown glaze and, before firing, cut through this to the paste, so that when fired the raw grey body contrasted with the glassy brown surface. Another innovation of the Yüan period was to paint rather fine designs in black with a black-hatched ground, and then to cover this with a transparent glaze stained either turquoise or green. Towards the end of the Sung Dynasty bowls decorated in overglaze red and green, and occasionally yellow, enamels appear. The design in the centre was of flowers, or lotus and fish, or more rarely a bird, surrounded by three or four red rings.

Underglaze Blue. Cobalt blue pigment applied for decorative purposes directly to the body, before glazing and firing. This was the usual technique used in the production of Chinese blue and white wares. The pigment was extracted from two types of cobaltiferous ore. (1) Mohammadan blue, an imported ore containing arsenic as an impurity, and (2) native cobalt, containing manganese as an impurity instead of arsenic. The differences between the two types is only distinguishable by analysis.

Wall Vase. A vase with one flat side, in which there is a slot for suspension from a hook on the wall. They probably do not date from much earlier than the latter part of the 16th century.

Wan Mark. A short writing of the character *wan*, 'myriad', 'ten thousand', is a swastika; it may be found used as a mark from the K'ang-hsi period (1662-1722) onward. [13*j*].

Water Dropper. A small vessel with only a small hole from which

87

the water may be shaken gently on to an ink-stone or paint palette. These vessels may be made in the form of an animal or fruit; the earliest examples are in Yüeh wares (q.v.) dating from the late Han or early Six Dynasties periods, when they were often in the form of a toad.

Wu-ts'ai, 'five colours', a term applied to porcelains of the Ming and Ch'ing Dynasties decorated in overglaze enamel colours, and often with coarsely-handled underglaze blue (q.v.); combined with red, green, yellow and black, and occasionally with a clear turquoise enamel as well. The outlines of the designs are drawn in overglaze black, dark brown, or red enamel, so that the type is easily distinguished from *tou-ts'ai* (q.v.). Some of the best examples date from the 16th century.

Ya-shou Pei, literally 'press hand cup', a name given to bowls having a flared mouth. [11*i*].

Yang-ts'ai. *See* FAMILLE ROSE.

Yen-yen. A large vase with wide neck and trumpet mouth; a dealer's term.

Yi-hsing potteries in Kiangsu, not far from Shanghai, still in production, are believed to have started operating in the 16th century. The kilns are best

known in the West for their reddish-brown unglazed stonewares, the teapots being especially famous. The decoration is usually either engraved, or in low relief. These wares exerted a strong influence on Friedrich Böttger of Meissen. Less well known are the glazed wares made in imitation of Chün (q.v.) and technically related to the wares of Kuangtung (q.v.).

Ying-ch'ing. *See* CH'ING-PAI.

Ying-ts'ai, 'hard colours', the Chinese term for *famille verte* (q.v.).

Yo-chou, the name given to wares which were excavated in the region of Changsha in 1946. These wares fall into three main groups. (1) A hard grey pottery or stoneware with ill-fitting glazes of green, straw colour or greenish-brown. (2) A Yüeh type (q.v.) celadon, distinguished from Yüeh in many cases on account of pronounced differences in form. (3) Porcelain with a clear slightly green-tinted glaze. The first group seems to date from the Han period onward, the second mainly from T'ang and the third group from T'ang onward. The glazes of the first two groups are frequently crackled and crazed, and sometimes, among the earlier pieces, iridescent; some of the glazes in the first group are fluxed

88

with lead. Nearly all the wares have the reddish soil in which they were buried adhering to them, or ingrained in the glaze, especially if this is crackled. The wares on present evidence appear for the most part to be of local manufacture.

Yü-hu-ch'un P'ing. *See* BOTTLE VASE.

Yü Mark. The character for jade used as a mark on wares of the K'ang-hsi period (1662-1722) and later.

Yü-yao. *See* SHANG-LIN HU.

Yüeh, an old principality at the mouth of the Yangtze, which has given its name to a grey-bodied ware with an olive-green or grey feldspathic glaze, fired at a fairly high temperature. The ware has a history reaching back into the 3rd or 4th century B.C., and is the first type of ware in China to be named *tz'ŭ*, porcelain. Until the T'ang dynasty, at the earliest, decoration was usually in the form of impressed bands of geometrical patterns with small animal masks of moulded relief luted on to the body before glazing. Many small models of toads, animals and even small buildings were common alongside the large jars, vases and bowls. During the T'ang dynasty the ware was much refined, the body becoming finer and more compact than formerly, and the glaze becoming more consistent in colouring and in some cases slightly opaque. During the 10th century the best of it is said to have been made exclusively for the princes of Yüeh, when it was called *pi-sě yao* 'reserved colour ware'. It continued in production into the earlier part of the Sung dynasty, but was gradually displaced by its derivative wares, Northern Celadon (q.v.) and the Southern Celadons of Lung-ch'üan (q.v.) and other kilns in Chekiang. It was exported throughout the Far East, South-East Asia, and the Near East, where it was much admired. It had a great influence on the ceramic wares of Korea.

Yüeh-pai. *See* CLAIR DE LUNE.

CERAMICS

RECOMMENDED BOOKS

BILLINGTON, D. *The Technique of Pottery*. London, 1962.

BRANKSTON, A. *Early Ming Wares of Ching-te-chen*. Peking, 1938.

BUSHELL, S. W. *Oriental Ceramic Art*. New York, 1899.

GARNER, SIR HARRY. *Oriental Blue and White*. London, 1954.

GOMPERTZ, G. *Chinese Celadon Wares*. London, 1958.

GRAY, B. *Early Chinese Pottery and Porcelain*. London, 1953.

HOBSON, R. L. *Chinese Pottery and Porcelain*. London, 1915.

HONEY, W. B. *The Ceramic Art of China and Other Countries of the Far East*. London, 1949.

JENYNS, S. *Ming Pottery and Porcelain*, London, 1953.

JENYNS, S. *Later Chinese Porcelain*. London, 1959.

LION-GOLDSCHMIDT, D. *Ming Porcelain*. London, 1978.

MEDLEY, M. *The Chinese Potter*. Oxford, 1976.

MEDLEY, M. *Yuan Porcelain and Stoneware*. London, 1974.

ORIENTAL CERAMIC SOCIETY *The Ceramic Art of China*. London, 1971.

POPE, J. A. *Chinese Porcelains from the Ardebil Shrine*. Washington, 1956.

TREGEAR, M. *Catalogue of Chinese Greenwares in the Ashmolean Museum*. Oxford, 1976.

VALENSTEIN, S. G. *A Handbook of Chinese Ceramics*. New York, 1975.

VOLKER, T. *Porcelain and the Dutch East India Company*. Leiden, 1954.

WIRGIN, J. *Sung Ceramic Designs*. Stockholm, 1970.

Transactions of the Oriental Ceramic Society, London, 1921 —. Also the catalogues of the Society's exhibitions.

DECORATION ✫

The decorative motives described in this section are generally to be found in all mediums, but are perhaps of commonest occurrence in ceramics. Terms relating to the decoration of archaic bronzes will be found in the Bronze section. The section of Buddhist terms may also be consulted in seeking to identify human figures.

Brocade Designs, designs, some of which derive from textiles. The term is generally associated with flowers, or close floral scrolls in bright colours against a pink, green, yellow or blue enamel ground which is sometimes incised with formal scrolling patterns. These designs are especially common from the Ch'ien-lung period onward.

Buddha's Hand Citron. *See* FINGER CITRON.

Ch'ang-ming Fu-kuei, 'Long life, riches and honours', a four character mark sometimes found on the base of a piece, but more usually found incorporated in some way in the decoration. It is probably not earlier than the Chia-ching period 1522-66.

Ch'i-lin, the fabulous creature known as a Kylin, sometimes called the Chinese unicorn. It may be leonine, with scales and horns, or it may be an elegant cloven-footed beast, with or without scales, with a bushy mane and tail, and a horn, or a pair of horns. Variations are extremely numerous and impossible to classify satisfactorily as the Chinese have, in the past, given this name to many animals, including the giraffe.

Chung K'uei, about whom there are many legends, is usually depicted as a Demon Queller, a

large ugly man wearing a scholar's hat, a green robe and large boots, with which he stamps on offensive looking imps. *See also* K'UEI HSING.

Classic Scrolls. A formal linear scrolling pattern of uncertain origin, common as a decorative band or border. It has a number of variations. [12*a*].

Cloud Collar, an important decorative device, variously referred to as 'ju-i pattern', or 'ogival panel', or 'lambrequins'. In its strict form it is four lobed panels set at right angles to each other, each one terminating in a point. The number of lobes to a panel varies. It is especially common in textile and porcelain decoration from the 14th century onward. [12*b*].

Cloud Scroll. A motive showing great variation, to be found in most mediums, but especially in ceramics, lacquer, cloisonné and textiles. [12*c-g*].

Cracked Ice. A blue and white background decoration in which the blue is painted on the body in such a way as to suggest this phenomenon. It may also occur in overglaze enamel decoration in

the 18th century, especially round the rim of a plate or dish.

Diamond Patterns. *See* TRELLIS PATTERN.

Diaper. Repeating geometrical patterns used as fillers or borders.

Dog of Fo, a Buddhist guardian lion, which from the 15th century onward occurs as a ceramic decoration and later as a statuette. It is a creature somewhat resembling a Pekinese dog, with a large bushy tail and is often shown playing with a brocaded ball to which ribbons are attached.

Eight Buddhist Emblems, or Happy Omens, often appear on the later ceramic wares, lacquers and cloisonné. The emblems are the Chakra or Wheel, the Conch Shell, the Umbrella, the Canopy, the Lotus, the Vase, the Paired Fish, and the Entrails or Endless Knot. A bell is occasionally substituted for the Chakra. At times some of these emblems may be mixed up with some of the Eight Taoist Emblems (q.v.), but so long as only eight emblems appeared in the decoration, it does not appear to have been very important which ones they were that made up the correct number.

PLATE 12. DECORATION. *a*] Classic Scrolls. *b*] Cloud Collar. *c-g*] Cloud Scrolls. *h*] Flaming Pearls. *i*] Eight Buddhist Emblems. *j*] Eight Precious Things.

a

b

c

d

e

f

g

h

i

j

PLATE 12

In Ming times, however, such substitution is rare. [12*i*].

Eight Horses of Mu Wang. The horses traditionally believed to have been used by King Mu of Chou (*c.* 950 B.C.) on his expeditions to subdue the barbarian tribes, and for his mythical journey to visit Hsi Wang Mu (q.v.). The horses are common both as a decorative motive and as small figures in jade and porcelain.

Eight Immortals were persons who, for various reasons and in divers ways, achieved immortality. Three were historical figures and the rest were purely legendary. The tradition is not believed to be earlier than the latter part of the Sung Dynasty. The eight are; (1) Li T'ieh-kuai, Li of the Iron-crutch, who always carries a crutch and a gourd; he is the emblem of the sick. (2) Chung-li Ch'üan, usually shown with a fan; represents the military man. (3) Lan Ts'ai-ho, the strolling singer, either a woman or a young boy, shown with a flower-basket; patron deity of florists. (4) Chang-kuo Lao, said to have lived in the 7th or early 8th century, shown as a rule with his mule, and carrying a bamboo tube-drum with iron sticks; he is the emblem of old men. (5) Ho Hsien-ku, a woman, said to have lived in the late 7th century, shown with a lotus blossom or flower basket, and occasionally with a peach and *shêng* reed-organ. (6) Lü Tung-pin, born *c.* A.D. 755, died A.D. 805, shown with a fly-whisk, is dressed as a scholar, and honoured as such. He also had a magic sword with which he performed great feats, for which reason he is also the patron deity of barbers. (7) Han Hsiang-tzǔ, said to be the nephew of the T'ang Dynasty statesman and scholar Han Yü, is often shown with a flute, and is patron deity of musicians. (8) Ts'ao Kuo-ch'iu, said to have been connected with the Sung Imperial family, and is generally shown with castanets or a jade tablet of admission to court; patron deity of actors.

Eight Immortals, Attributes of. *See* EIGHT TAOIST EMBLEMS.

Eight Musical Instruments as motives of decoration are the *Ch'ing*, or Musical Stone; the *Chung*, or Bell; the *Ch'in*, or Lute; the *Ti*, or Flute; the *Chu*, a box with a metal hammer inside; the *Ku* or Drum; the *Shêng*, or Reed Organ; the *Hsüan*, or Ocarina. Of these the Musical Stone is included in the category of Eight Precious Things (q.v.), and the Bell may sometimes be substituted for the Chakra, or Wheel, in the category of Eight Buddhist Emblems (q.v.).

Eight Precious Things, or *Pa pao*, often occur as decorative motives and occasionally individually as marks. They are the Jewel; the Cash, a circle enclosing a square; the Open Lozenge with ribbons; the Solid Lozenge, also with ribbons; the Musical Stone, a roughly L-shaped object suspended from the angle; the Pair of Books; the Pair of Horns, and the Artemisia Leaf. The last is particularly common as a ceramic mark, especially in the K'ang-hsi period. [12*j*].

Eight Taoist Emblems, or attributes of the Eight Immortals. These sometimes appear on the later ceramic wares and are the Fan, carried by Chung-Li Ch'üan; the Sword of Lü Tung-pin; the Gourd of Li T'ieh-kuai; the Castanets of Ts'ao Kuo-ch'iu; the Flower-basket of Lan Ts'ai-ho; the Bamboo tube and Rods—a kind of drum—of Chang-kuo Lao; the Flute of Han Hsiang-tzŭ, and the Lotus of Ho Hsien-ku. [13*e*]. These emblems may sometimes be confused with the Eight Buddhist Emblems (q.v.), but so long as eight appeared it does not seem to have mattered which ones were used. These emblems are called in Chinese, *Pa-an Hsien*.

Eight Trigrams, eight groups of lines, each group consisting of combinations of broken and unbroken lines, arranged in three ranks. They are traditionally said to have been invented by the legendary hero Fu Hsi, and formed the basis of an ancient system of philosophy and divination. They seem to have become a decorative motive in ceramics, metalwork, and perhaps other mediums, from about the 14th century onward; often found associated with the *Yin-yang* device (q.v.). [13*a*].

False Gadroons. *See* LOTUS PANELS.

Fêng-huang. *Fêng*, the male phoenix and *huang*, the female; combined to form a single generic name. The phoenix is an emblem of the empress. It is also called the 'Ho-ho bird', Ho-ho being the Japanese name; this term is generally only found in older books on Chinese art.

Finger Citron, the Chinese *Fo-shou*, 'Buddha's Hand', identified with *Citrus medica*, *var. sarcodactylis*.

Five Blessings, or *Wu fu*, literally the five happinesses, symbolised either by the character *fu*, 'happiness' repeated five times, or by five bats, also called *fu*. The Five Blessings are long life, riches, tranquillity, a love of virtue and a good end to crown one's life,

Flaming Pearl, a motive usually found in association with dragons, it occurs in most mediums. [12*h*].

95

Flowers of the Four Seasons. Prunus for winter and symbolic of beauty; peony for spring and wealth, lotus for summer and purity, and the chrysanthemum for autumn and steadfast friendship.

Flowers of the Twelve Months. These are, in order from the first month, prunus, magnolia, peach, rose, crab-apple, peony, lotus, pomegranate, mallow, chrysanthemum, orchid and narcissus. This order is not invariable, and sometimes other flowers are substituted. They occur in all mediums, being especially popular in lacquer and textiles.

Gadroons. *See* LOTUS PANELS.

Hai-ma, 'Sea horses', horses sporting among waves; common from the 15th century onward, first in blue and white, and then in other porcelains and mediums as well.

Hai-shou, sea beasts, a common motive of decoration, including real as well as fabulous beasts.

Hawthorn Design. *See* PRUNUS PATTERN.

Ho-ho. *See* FÊNG-HUANG.

Ho-ho Êrh-hsien. *See* TWIN GENII OF MIRTH AND HARMONY.

Hsi Wang Mu, the Queen Mother of the West, usually shown as a beautiful woman accompanied by girls known as Jade Maidens, carrying flowers and peaches. She was believed to guard the peaches of immortality.

Hui-hui Wên. The so-called Mohammadan scrolls, a type of scrolling decoration which first occurs on blue and white porcelains of the Chêng-tê period (1506-21), in the Ming dynasty, on pieces made for the eunuchs in the imperial palace and which bear inscriptions in Arabic or Persian. The scrolls are easily recognisable by their outline and thin wash technique.

Hundred Antiquities, or *Po-ku*, are used as decorative motives, mainly from the K'ang-hsi period (1662-1722) onward, and are drawn from many sources, both sacred and profane. The term 'Hundred' can only be accepted as implying multiplicity. The most common objects to fall into

PLATE 13. DECORATION. a] Eight Trigrams. b] Lappet. c] Yin-yang. d] Ling-chih. e] Eight Taoist Emblems. f] Lotus Panel. g] Petal Diaper. h] Shou Characters. i] Shuang-hsi. j] Swastika Lozenge. k] Trellis Patterns.

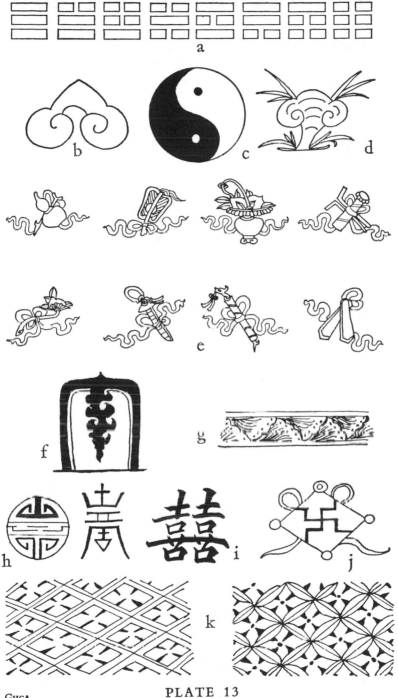

this group are the archaic bronzes and objects from the scholar's study.

Hundred Children. A general term for designs in which a large number of children appear at play.

Hundred Flowers. *See* MILLE-FLEURS.

Isles of the Blest. The island home of the Taoist immortals in the Eastern Sea. Commonly shown as a luxuriant landscape, with lakes and rivers, birds and animals, especially the deer and crane, which were symbolic of immortality.

Ju-i Lappets. *See* LAPPETS.

Key Fret. A repeating design used as a band or a filler; found on ceramics, lacquer and cloisonné.

Kinrande, 'gold brocading', a Japanese term for gilt decoration on red or green enamelled bowls and vases. It may also occur on blue-painted bowls, and very rarely on plain white porcelain. It seems to have been an innovation of the Chia-ching period (1522-66) and became exceptionally popular in Japan.

Ku-yüeh Hsüan, the name by which a singularly fine type of polychrome enamelled ware of the 18th century is known. Most pieces are small and are decorated with opaque enamels in a minutely delicate style. The subjects are almost invariably floral, and may be executed on porcelain or on an opaque milky-toned glass; pieces are generally marked in blue enamel. It is rare, highly valued and of a short life, achieving the height of perfection between 1727 and 1754.

Kuan Ti. The God of War, Kuan Yü. He lived in the period of the Three Kingdoms; he officially became a god in the Wan-li period (1573-1619), and is usually shown as an ugly man in full armour, brandishing a sword. He is, however, also worshipped as a secondary God of Literature and in this form can be confused with Wên Chang Ti Chün (q.v.) again appearing as a bearded man, but with a book in his hand. In this form he may also be confused with K'uei Hsing (q.v.). The precise individual intended is often very difficult to determine. Kuan Ti gained his secondary form on the strength of his reputed ability to recite the *Spring and Autumn Annals* and Tso's commentary right through from beginning to end.

K'uei Hsing, a God of Literature distinguished by his ugliness and his special attribute, the Fish-dragon, which is an emblem of literary prowess. K'uei Hsing replaced the principal God of

Literature, Wên Chang Ti Chün (q.v.), in the popular mind and was canonised in the 14th century. He can sometimes be confused on account of his beard and fierce aspect with Kuan-ti (q.v.).

Kylin. *See* CH'I-LIN.

Lambrequin. *See* CLOUD COLLAR.

Lange Lijsen. *See* LONG ELIZAS.

Lappets, often called 'ju-i lappets', this motive resembles the head of the curved *ju-i* sceptre, a ceremonial object carried by certain Buddhist deities and an emblem of monastic authority. The motive itself is nearly heart-shaped and occurs commonly as a repeating band pattern. It is very similar, on a small scale, to the cloud collar motive (q.v.) for which the term lappets is often, and perhaps mistakenly, used. [13*b*].

Ling-chih. The sacred fungus, identified as *Polyporus lucidus*, symbolic of longevity. It occurs in decoration with other longevity symbols such as the peach, the crane and pine tree. [13*d*].

Liu Hai. An immortal who caught a three-legged toad with a string of cash. He is invoked by those seeking success in commercial undertakings.

Long Elizas, a term derived from the Dutch *lange lijsen*, descriptive of the somewhat elongated female figures found on 17th- and early 18th-century porcelains, which the Chinese call *mei-jên*, 'beauties'.

Lotus Panels, a decoration used mainly as a border motive, either upright or pendant. [13*f*]. It derives ultimately from the lotus petals of the Buddhist lotus throne (*Padmasana*). There are many forms of stylisation, but all go back to the petal with the tip turned back a little. It is frequently referred to, mistakenly, as 'gadroons', 'false gadroons' or 'lambrequin'.

Mei-hua, plum blossom. A motive of decoration, that may also occur as a mark.

Mei-jên, beauties, graceful women. *See also* LONG ELIZAS.

Millefleurs, a decoration which consists of an all-over scattering of flower heads in many colours. A style of decoration dating from the latter part of the 18th century onward.

Mohammadan Scrolls, the decorative scroll patterns that first occur on blue and white porcelains in the Chêng-tê period (1506-21), called by the Chinese *hui-hui wên*. The scrolls are outlined rather firmly and then filled in

99

with a slightly paler tone of blue. The term is fairly commonly applied to this style of scroll pattern in other mediums as well, especially to those appearing in cloisonné.

Mu Wang Pa-chün Ma. *See* EIGHT HORSES OF MU WANG.

Pa An-hsien. *See* EIGHT TAOIST EMBLEMS.

Pa Chi-hsiang. *See* EIGHT BUDDHIST EMBLEMS.

Pa Hsien. *See* EIGHT IMMORTALS.

Pa-kua. *See* EIGHT TRIGRAMS.

Pa Pao. *See* EIGHT PRECIOUS THINGS.

Pa Yin. *See* EIGHT MUSICAL INSTRUMENTS.

Pao-shan Hai-shui, 'precious mountains and sea waters', a design found round a lower edge or border, consisting of waves breaking against stylised rocks; common to most mediums. It may also be called 'rock of ages ground'.

Petal Diaper, a motive common to most mediums, consisting of elliptical motives set at right angles to each other. [13*g*].

Po-Hua. *See* MILLEFLEURS.

Po-ku. *See* HUNDRED ANTIQUITIES.

Precious Pearl. *See* FLAMING PEARL.

Prunus Pattern. A pattern of flowering prunus with petals falling on cracked ice (q.v.); a design symbolic of the passing of winter and the coming of spring. It may sometimes be found referred to as 'Hawthorn design', and objects upon which it appears are sometimes described as hawthorn vases or jars.

Pu-tai-ho-shang, or simply Pu-tai, lived in late T'ang times. The 18th Lohan (Arhat; see Buddhist terms), he is represented as a fat man with the upper part of his abdomen exposed to view. He often has a bundle of books and either a fly-whisk or a pilgrim's staff. He is regarded as one of the manifestations of Maitreya, the Buddha of the future.

Rock of Ages Ground. A dealers' description of waves breaking over stylised rock formations; often used as a base line for dragons or other creatures. *Pao-shan hai-shui* is the correct Chinese name.

San Ch'ing, the Three Pure Ones of the Taoist trinity, apparently introduced as counter-propaganda to the Buddhist trinity of the

Buddha and two Bodhisattvas. The three Taoist figures are shown as dignified gentlemen with beards, seated on thrones.

San-yu. *See* THREE FRIENDS.

Seven Sages of the Bamboo Grove. A group of famous men of letters in the 3rd century A.D., who are reputed to have met constantly in a bamboo grove to drink wine and discuss literature. Their names are given as Hsiang Hsiu, Chi K'ang, Liu Ling, Shan T'ao, Juan Chi and his nephew Juan Hsiao, and Wang Jung, but they were not in fact all alive at the same time. They are usually shown in a rocky landscape shadowed by sprays of bamboo, drinking wine and sometimes accompanied by a young boy who serves them.

Shan-shui Scenes. Landscapes.

Shou Characters. Conventionalisations of the character *shou* meaning long life. [13*h*].

Shou Lao. The Star God of Longevity. An old man with a high forehead and long white beard, usually shown with a peach in one hand and a staff in the other, accompanied by a deer or a crane, and sometimes by both. He is often included in designs with the Eight Immortals (q.v.).

Shu Wa-wa. *See* WA-WA.

Shuang-hsi, 'Two-fold joy' or wedded bliss. A mark that occurs on both porcelains and enamels intended as gifts. The motive consists of two *Hsi* characters placed side-by-side, often with the lowest horizontal bar running right across to unite the two characters. [13*i*].

Swastika Lozenge. A mark that may be used as a decorative motive. [13*j*].

Three Abundances, the peach, the pomegranate and persimmon, symbolic of long life, a numerous progeny and happiness; the persimmon is sometimes replaced by the finger citron (q.v.).

Three Friends, prunus, pine and bamboo, all emblems of longevity and of winter, are also symbolic of the qualities of the gentleman. The prunus is associated with good looks and sturdy independence in that it flowers at a time when nothing else appears to grow. The pine is symbolic of the constancy of friendship in the time of adversity, and of endurance. The bamboo, known for durability, is symbolic of the integrity of the scholar and gentleman who remains loyal in adversity. These three are also symbolic of the three religions of China, Taoism, Buddhism and Confucianism.

Trefoils. *See* LAPPETS.

Trellis Pattern, a repeating geo-metrical pattern used for borders, or as a filler. There are several forms of it. [13*k*].

Twelve Symbols. These are associated mainly with imperial robes, but some occur alone, and in other mediums than textiles. [14]. The symbols are; Sun [*a*], Moon [*c*], Constellation [*b*], Mountains [*d*], Dragon [*e*], Pheas-ant [*f*], Bronze Sacrificial Cups[*g*], Water Weed [*h*], Grain [*i*], Fire [*j*], Axe [*k*] and *Fu* [*l*] symbol. Sun, Moon and Constellation are symbols of enlightenment and of Heaven, the Mountains of pro-tection and Earth. The Dragon is symbolic of adaptability, on account of the transformations of which it is capable, and the Pheas-ant is symbolic of literary refine-ment, and the two together represent animals and birds, or animate nature. The Bronze Sacrificial Cups symbolise filial piety, the Water Weed purity, Grain, ability to feed the people and Fire, brilliance; these four, to-gether with the Mountains repre-sent the Five Elements, Metal, Water, Fire, Plant life (Wood) and Earth. The Axe represents the

power to punish, and the *Fu* symbol, the power to judge. These symbols are often carried out in textiles in the Five Colours, red, blue, yellow, green and white, and correspond to the Five Elements, Seasons and Directions. Only the emperor was entitled to display all twelve, the last two being his special emblems of authority. The Sun disc is us-ually red and contains the three-legged crow, and the Moon is a pale watery blue or green and encloses the Hare pounding the Elixir of Life. When all twelve symbols appear on a robe, it assumes cosmic significance in the sense that it is symbolic interpre-tation of the Universe, and the emperor wearing it then repre-sents the Ruler of the Universe.

Twin Genii of Mirth and Har-mony. Patron deities of mer-chants, potters and lime burners. They are shown as two short, fat men laughing heartily; they are often associated with gods of wealth. In Chinese they are called *Ho-ho êrh Hsien.*

Tung Fang Shuo. 'First of the Eastern Moon.' A patron deity of goldsmiths and silversmiths, said to be a re-incarnation of the

PLATE 14. DECORATION. The Twelve Symbols. *a*] Sun. *b*] Con-stellation. *c*] Moon. *d*] Mountains. *e*] Dragon. *f*] Pheasant. *g*] Bronze Sacrificial Cups. *h*] Water Weed. *i*] Grain. *j*] Fire. *k*] Axe. *l*] Fu Symbol.

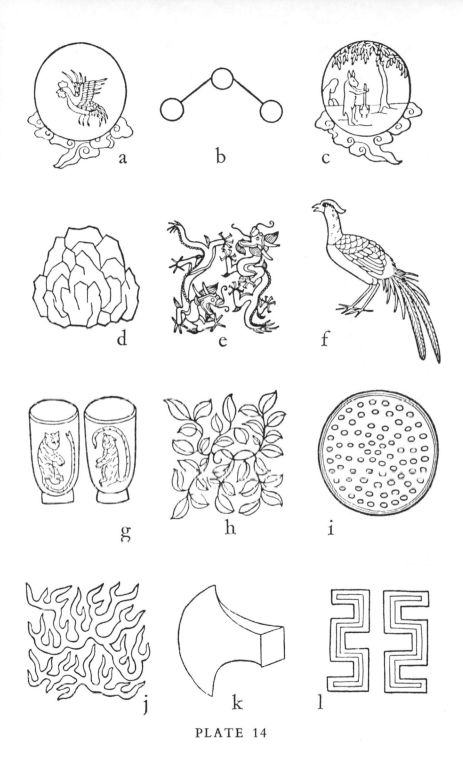

PLATE 14

spirit of the planet Venus, and usually represented with his feet on gold and silver ingots.

Wa-wa, children; designs with children are so named because this is the sound they are supposed to make when first learning to speak.

Wên Chang Ti Chün. The principal God of Literature, represented in decoration as a dignified figure in official dress, wearing a broad-brimmed hat, riding on a mule and accompanied by attendants with banners. He was really a stellar divinity and was replaced in popularity by K'uei Hsing (q.v.) in about the 14th century.

Willow Pattern, which used to be thought a Chinese design, is in fact an English interpretation of a Chinese story set in a landscaped pleasure ground. It first appeared on blue transfer-printed earthenware in about 1800. The design was later copied by the Chinese in painted blue and white porcelain, thus giving rise to the belief that the whole design was of oriental origin.

Wu-fu. *See* FIVE BLESSINGS.

Wu Lao. The Five Old Men, the spirits of the Five Elements, metal, wood, water, fire and earth. They are named Wang Mu, Mu Kung, Shui Ching-tzǔ, Ch'in Ching-tz[u] and Huang Lao.

Yin-yang. A circle divided into two equal parts by an S-curving line, one half being rendered dark (Yin), representing the female principle and relating to earth, moon, darkness and so on, and the other half being light (Yang), representing the male principle and relating to heaven, sun, light and so on. In decoration this dualistic cosmological symbol often appears together with the Eight Trigrams (q.v.). [13c].

DECORATION

RECOMMENDED BOOKS

CAMMANN, S. *Chinese Toggles.* Philadelphia, 1962.
SOWERBY, A. DE C. *Nature in Chinese Art.* New York, 1940.
WERNER, E. T. C. *Myths and Legends of China.* London, 1922. Reprinted 1962.
WERNER, E. T. C. *A Dictionary of Chinese Mythology.* Shanghai, 1932.
WILLIAMS, C. A. S. *Outlines of Chinese Symbolism and Art Motives.* Shanghai, 1932; reprinted 1962.

JADE AND
HARDSTONES ☆

In Europe and America we use the word 'jade' to indicate two minerals, nephrite and jadeite, but the Chinese word *yü*, while it may mean these two is also used to indicate any precious or beautiful stone; it may also be found in literature used in contexts that make it clear that beauty or purity are meant. For our present purpose jade means nephrite and jadeite, which in appearance, hardness, texture, and often in colour are so much alike that only chemical or spectrographic analysis make it possible to distinguish one from the other.

Nephrite is a silicate of calcium and magnesium, and generally contains iron; it is a member of the amphibole group of minerals and is identical in composition with actinolite. According to Mohs' scale of hardness, it is placed at $6\frac{1}{2}$; the specific gravity is 3·0 and it has a fine grain and is fibrous; the physical properties of nephrite differ from those of jadeite.

Jadeite is a silicate of aluminium and sodium, containing small quantities of iron, calcium and magnesium. The hardness is 7, the specific gravity is 3·33, and it is granular or fibrous, more commonly the former. It does not appear on present evidence, to have been worked in China before the 18th century, when it was imported from Upper Burma.

Both minerals are tough and, paradoxically, brittle.

Ch'ing. A musical stone; a roughly L-shaped flat stone of jade or other material, suspended from a frame by a cord that passes through a hole drilled at the angle of the two arms. Such stones may be hung as a chime, or very large ones may be suspended alone. [15*a*].

Fei-ts'ui. Burma jadeite of brilliant green colour. The name originally meant a kingfisher, and may also be used nowadays to mean kingfisher feathers.

Halberd. A ritual jade, also called *ko*, which became a badge of rank; it is similar to the bronze form (*see* BRONZE). The tang of a jade halberd is often ornamented with narrow ridges or cross-hatchings. [15*b*].

Han. Jades placed in the mouth of the dead; usually in the form of a cicada.

Hsüan-chi, a jade object resembling the *pi* (q.v.) with a serrated edge. It is believed to have been used in connection with astronomical observations. [15*d*].

Hua-shih, literally 'slippery stone'; often to be interpreted as steatite or soapstone, but in contexts relating to ceramics it should be taken to mean a natural white-firing clay related to kaolin (*see* CERAMICS).

Huan. A disc with a circular concentric hole of rather larger diameter than that of the *pi* (q.v.). This type may perhaps have had ritual significance. [15*c*].

Juan Yü. Soft jade, a modern term for nephrite.

Koro. A Japanese term meaning 'incense burner', frequently found in texts on Chinese jade. It refers as a rule to vessels resembling the archaic bronze form *kuei* (q.v.), but unlike most bronze examples, is raised on three short legs.

Ku-wên. *See* RICE GRAIN PATTERN.

Kuei. A sceptre; this broadly takes two forms. One type is an elongated flat tablet with a slight point at one end, sometimes decorated with rice grain pattern (q.v.); it was used as an emblem of office, or as insignia of the nobility. [15*k*]. The other type somewhat resembles the halberd (q.v.), but the blade instead of coming to a point, widens and has an arc cut out of the end; this too was an emblem of office or badge of rank. [15*g*].

Mutton Fat Jade, in Chinese *yang-chih-yü*. A pure white nephrite, which when well polished has a slightly greasy, lard-like

appearance. This type has always been highly esteemed.

Pao-liao. *See* PAO-YAO.

Pao-yao, the Chinese name for the abrasive powder used for polishing jade. Bushell refers to it as *pao-liao*.

Pi. A ritual jade. It is a flat disc with a circular concentric hole of about one-third of the total diameter. The symbol of heaven and used at the sacrifices to Heaven from antiquity down to the end of the Ch'ing Dynasty in 1911. [15*e*].

Po-ts'ai-yü. *See* SPINACH JADE.

Rice Grain Pattern. In Chinese *ku-wên*; small protuberances, equidistant from each other over a surface. These protuberances are sometimes ornamented with engraved curls.

Siberian Jade. *See* SPINACH JADE.

Skin. The reddish-brown oxidized covering of a jade pebble. It is often partly retained in carved jade on account of its decorative effect.

Spinach Jade. In Chinese *po-ts'ai-yü*; a nephrite from Siberia characterised by black flecks of graphite. Not all jade from this area, however, displays this feature. Much of the material comes from the Lake Baikal region.

Sword Furniture. Four fittings may be made of jade. (1) The disc fitting into the end of the hilt. (2) The guard. [15*h*]. (3) The chape on the end of the scabbard. [15*i*]. (4) The sling fitting, placed vertically on the scabbard for suspending the sword from the belt. [15*l*].

Ts'ui-yü. *See* FEI TS'UI.

Tsung. A ritual jade. A cylindrical tube in a rectangular piece of jade. [15*f*]. Such objects vary greatly in size, small ones resembling rings, while large ones may stand up to 18 inches in height, and may taper a little towards one end. [15*j*]. It is regarded as a symbol of Earth.

Ya-chang. A jade sceptre in the form of a knife, somewhat resembling the halberd (q.v.). An emblem of rank and used for ceremonial purposes.

PLATE 15. JADE. *a*] Ch'ing. *b*] Halberd. *c*] Huan. *d*] Hsüan-chi. *e*] Pi. *f*] Tsung. *g*] Kuei. *h*] Sword Furniture, the guard. *i*] The chape. *j*] Tsung. *k*] Kuei. *l*] Sword Furniture, the sling fitting. *m*] Yüan.

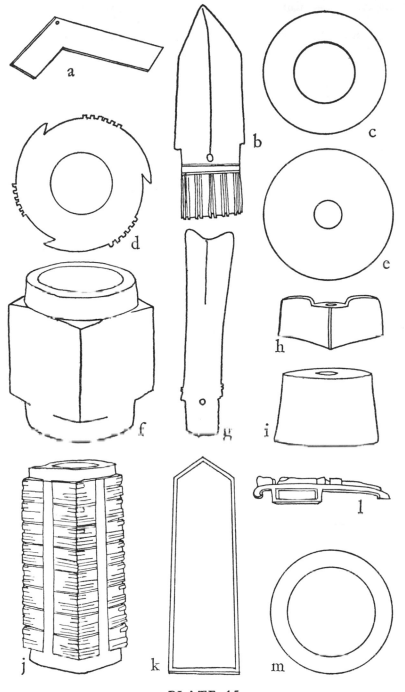

PLATE 15

Yang-chih-yü. *See* MUTTON FAT JADE.

Ying-yü. Hard jade, a modern term for Burma jadeite.

Yü. The Chinese name for jade and gems; in the context of literature it conveys a sense of beauty and purity. The character some- times occurs as a mark on porcelain, and then means beauty.

Yüan. A disc with a very large circular orifice, giving the object the appearance of being simply a ring. So far as is known such an object had no ritual significance, and the word is often used as a term for rings in general. [15*m*].

JADE AND HARDSTONES

RECOMMENDED BOOKS

d'ARGENCE, R.-Y. L. *Avery Brundage Collection of Chinese Jades.* San Francisco, 1972.

DOHRENWEND, D. *Chinese Jades in the Royal Ontario Museum.* Toronto, 1971.

HANSFORD, S. H. *Chinese Jade Carving.* London, 1950.

JENYNS, S. *Chinese Archaic Jades in the British Museum.* British Museum, London, 1951.

LAUFER, B. *Jade: A Study in Chinese Archaeology and Religion.* Chicago, 1912.

LOEHR, M. *Ancient Chinese Jades*, Fogg Art Museum. Cambridge, Mass., 1975.

MINNEAPOLIS INSTITUTE OF ART. *Chinese Jades: Ancient and Modern.* London, 1977.

ORIENTAL CERAMIC SOCIETY. *Chinese Jade throughout the ages.* London, 1975.

SALMONY, A. *Carved Jade of Ancient China.* Berkeley, Calif., 1938.

SALMONY, A. *Archaic Chinese Jades from the Collection of Edward and Louise B. Sonnenschein.* Chicago, 1952.

WHITLOCK, H. P. & EHREMANN, M. L. *The Story of Jade.* New York, 1949.

PAINTING ☆

The immense and complicated problems of Chinese painting make any comprehensive listing and definition of terms, at the present time, almost impossible and certainly beyond the scope of this general handbook. The terms included in the following pages are necessarily an arbitary selection, most of them from a famous Chinese manual of painting produced in the late 17th century. They are intended simply to provide those interested in the subject with a rough guide to what seem to be the most important, and to those most likely to be encountered in European and American books and catalogues.

The books listed at the end of the section will provide material on the historical aspects, as well as on the best-known painters of each period.

Albums. These, usually with wood, or brocade-covered card covers, are not as a rule more than 18 inches in height or width. They consist of up to a dozen pages, occasionally more, and may include both paintings and examples of calligraphy, often with a picture facing a poem.

Alum used in combination with size in the preparation of silk for painting. The alum helps to give a smooth, very slightly glossy surface.

Banners. These are paintings on silk, or less expensive woven textile, that are hung up in temples, and which may be carried in procession. The subject matter is almost invariably Buddhist.

PLATE 16. PAINTING. Brush Strokes: Bamboo. a-c] Stems. d-i] Leaves.

PLATE 16

Boneless Painting. *See* TECH-NIQUES.

Broken Ink. *See* TECHNIQUES, *Po–mo.*

Brush. In Chinese *pi*. Graded hair held together with adhesive and inserted in the end of a bamboo tube; it has a fine flexible point. The most common types of hair are goat, deer, fox, weasel and pig. Brushes vary a great deal in size, both as to length and thickness.

Brush Strokes. The types of brush strokes and the names given to them by the Chinese are extremely numerous; the following is no more than a selection of what might be termed basic strokes, which can be combined in almost innumerable ways in making up the structure of a picture. For convenience they are grouped according to subject, as they are in Chinese manuals of painting.

BAMBOO. [16].
Lu-chüeh, 'Stag's horns' for stems. [*a*].
Chüeh-chao. 'Bird's claw' for stems. [*c*].
Yü-ku, 'Fish bone' for stems. [*b*].
Fei-yen, 'Wild goose in flight', three strokes for leaves. [*e*].

Yü-wei, 'Fish tail', two strokes for leaves. [*d*].
Yen-wei, 'Swallow tail', two strokes for leaves. [*g*].
Ching-ya, 'Startled crow', four strokes for leaves. [*h*].
Lo-yen, 'Goose alighting', four strokes for leaves. [*i*].
Fei-yen, 'Swallow in flight', five strokes for leaves. [*f*].

TREES
The strokes for trees can be divided into three types. (1) Those for branches and twigs. [17]. (2) Dotting strokes for foliage in ink painting. (3) Outline strokes for foliage when painting in ink and colour, for which no specific names are given. [18].
Lu-chüeh, 'Stag's horns', short strong strokes for upward reaching twigs, giving a vertical impression. [17*a*].
Hsieh-chao, 'Crab claw', short downward curving strokes giving a drooping appearance. [17*b*].
Hu-shu tien, pepper dots, for foliage. [17*d*].
Hsiao-hun tien, small eddy dots, for foliage. [17*c*].
Chieh-tzŭ tien, dots like the character *chieh*, for foliage. [17*e*].
Mei-hua tien, plum blossom dots, five dots in a cluster for foliage. [17*g*].
Shu-tsu tien, mouse track dots for foliage. [17*f*].

PLATE 17. PAINTING. Brush Strokes: Trees. *a–b*] Stems and Twigs. *c–n*] Foliage.

a

b

c

d

e

f

g

h

i

j

k

l

m

n

PLATE 17

Ko-tzŭ-tien, dots like the character *ko*, for foliage. [17*h*].

Sung-yeh tien, pine needle dots. [17*i*].

Ch'in-t'êng tien, hanging vine dots, for foliage. [17*j*].

Chü-hua tien, chrysanthemum flower dots, for foliage. [17*k*].

P'o-pi tien, split brush dots, for foliage. [17*l*].

Yang t'ou tien, upward turned dots for foliage. [17*m*].

P'ing t'ou tien, level dots for foliage. [17*n*].

ROCKS

Chieh-so, ravelled rope. [19*a*].

Ta-fu-pi, large axe-cuts. [19*b*].

Hsiao-fu-pi, small axe-cuts. [19*c*].

Luan-ch'ai, brushwood in disorder. [19*d*].

P'i-ma, spread-out hemp fibres. [19*e*].

Chih-ma, strokes like sesamum seeds, usually combined with *p'i-ma* above. [20*a*].

Ho-yeh, veins in a lotus leaf. [19*f*].

Chê-t'ai, iron bands. [20*c*].

Yün-t'ou, cloud heads. [20*b*].

MOUNTAINS

Luan-ma, tangled hemp. [20*e*].

Mo-lê, outlines like veins. [20*d*].

Chi-mo, massed ink; combined with *p'o-mo*, 'splashed ink' and *chiao-mo*, 'dry ink' by the Sung period artist Mi Fei and his followers and successors. [20*f*].

Chieh-hua. Drawing with square and rule; used in the meticulous representation of architecture, especially in association with *Ch'ing-lu shan shui* (q.v.), and in genre painting, particularly in the later periods.

Chih. *See* PAPER.

Ch'in Shou. *See* SUBJECTS.

Ch'ing-lu Shan-shui. *See* TECHNIQUES.

Chüan. *See* SILK.

Colophons. In Chinese *t'i-pa*. These are strictly speaking prose annotations and may be written by the painter, his friends, or by later collectors. Poetic colophons are *t'i-shih*, and are usually in praise of, or inspired by the painting.

Copies. There are three types. (1) *Fang*, a free, or interpretive, copy. (2) *Mu*, to copy by transfer, or tracing. (3) *Lin*, to copy with the original alongside. All three are important in the training of the artist.

Dots. In Chinese *tien*. Dots are used in ink or in colour for emphasis or better definition of planes and contours. They are

PLATE 18. PAINTING. Brush Strokes: Trees, unclassified foliage strokes for ink and colour.

PLATE 18

also used on rocks and trees to suggest lichens. Excessive use of dots in connection with emphasis and definition is regarded as a fault that weakens the whole picture. Foliage dots, which are subject to classification, will be found under Brush Strokes.

Fans. These are either nearly circular, or curved and folding like the European fan. The second type is later and was to be the type introduced to the West. Landscape and flower subjects are commonest, but calligraphy alone may be used. They were often painted to give as presents on particular occasions, and many are dated.

Flying White. See Techniques.

Hsieh-i. See Techniques.

Hsieh-shêng. To draw from the life.

Hsüan-jan, colour washes shading from light to dark, or from one colour to another.

Hua Chüan. See Picture Silk.

Hua-hui. See Subjects.

Ink. In Chinese *mo*. Lampblack combined with glue and moulded into sticks and cakes.

The stick is rubbed down, on a stone or palette, to the consistency required with water.

Jên-wu. See Subjects.

Kan-pi. See Techniques.

Kung-pi. See Techniques.

Mounting. There are various ways of mounting pictures, but that most commonly used is given here for hanging pictures. (1) *T'ien-ti*, heaven and earth, the extreme top and bottom of the mount, the top area being greater than the bottom, both areas being of a different coloured silk from (2) *Ssŭ-hsiang*, the quadruple border, the narrow band of silk round all four sides of the picture area itself; again the top area is greater than the bottom. (3) *Yang-chü*, protective strips of brocade or silk, one at the top and one at the bottom. (4) *Fêng-tai*, 'wind bands', the two decorative strips hanging from the top of the scroll. (5) *Chou*, the wooden roller on which the picture is rolled. (6) *Chou-shou*, the ornamental ends of the roller, for which any of the following may be used, hardwood, horn, ivory, porcelain or jade. (7) *Piao*, labels, narrow strips on the outside of the rolled picture, which usually record the dynasty,

PLATE 19. PAINTING. Brush Strokes: Rocks.

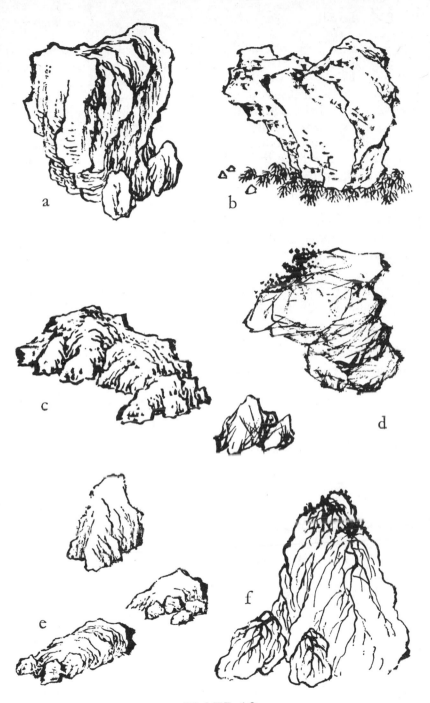

a

b

c

d

e

f

PLATE 19

artist's name and the title of the picture. There may be in addition the *shih-t'ang*, poetry hall, paper mounted immediately above the picture, between it and the *ssŭ-hsiang*, for annotations. In handscrolls this area is called the *t'o-wei chih*, 'towed at the end paper,' a long strip at the left end of the painting.

Pai-Miao. Outline drawing in ink only, without shading or washes. *See also* SHUANG-KOU.

Paper. In Chinese *chih*. Used for painting, it may be manufactured from rice straw, hemp, mulberry, certain types of reed and bamboo, besides other materials. Bamboo paper is generally supposed to be the best.

Pi. *See* BRUSH.

Picture Silk. *Hua-chüan* in Chinese. This is the name given to ready-prepared silk, when sizing has been completed.

Pigments. These are either mineral or vegetable. Blues are derived from azurite or indigo. Greens are from malachite; yellows from orpiment and realgar, or from the natural sap of the rattan cane; vermilion in various shades derives from cinnabar, a sulphide of mercury; umber is from a spe-cial variety of iron oxide called limonite. Carmine and crimson shades, including pinks are derived from a vine with red flowers and leaves. Umber combines well with the vegetable colours and is used especially to produce a wide range of ochres for landscape and flower painting. There are two whites, lead white from lead oxide, and chalk white, or lime white, produced by burning sea shells; this latter white was the more expensive, but was better because discoloration with age or as the result of exposure was unknown.

P'o-mo. *See* TECHNIQUES.

Porcelain Blue Silk. In Chinese *Tzŭ-ch'ing chüan*. A very dark blue silk used for Buddhist and flower subjects and also as a ground for characters written in gold.

Scrolls. These are of two types; the hanging scrolls, with the picture area generally higher than the width, and the handscrolls, horizontal pictures varying a great deal in length, and not as a rule intended to be seen completely at once. The handscroll is intended to be unrolled on a table, bit by bit, so that only about 18 inches or so are visible at a time. The Japanese terms relating to these

PLATE 20. PAINTING. Brush Strokes: Rocks *a–c*. Mountains *d–f*.

PLATE 20

two forms are *kakemono*, hanging scrolls, and *makemono* 'unrolling thing', the handscroll.

Seals. These are the vermilion 'chops' or signatures that appear on both paintings and calligraphy. They may be affixed by the artist, or his friends or by collectors and connoiseurs. Sometimes they record a name and sometimes a commendatory phrase. They are generally square, but may be round or oval, and on rare occasions a fancy form such as a gourd.

Shan-shui. *See* SUBJECTS.

Shuang-kou. Outline, or double contour; used in connection with the outline style of orchid, bamboo and foliage painting. The term *kou-lê*, outline, may also be used.

Silk. In Chinese *chüan*. A general term for this common ground for painting.

Six Canons of Painting. Formulated by Hsieh Ho in about A.D. 500, these Canons have always dominated the aesthetics of Chinese painting, and have been a yard-stick for standards of criticism. There is much controversy over their proper interpretation into English, especially of the first one, from which the others follow. The interpreta-tions here given must not therefore be regarded as more than a general guide.

(1) Spirit Resonance, which means vitality.
(2) Structure means using the brush.
(3) In accordance with the object, draw its form.
(4) According to the nature, lay on the colours.
(5) Division and planning means composition.
(6) In transmitting copies, transmit what was drawn.

Discussion of these Canons will be found in most of the books on Chinese painting, quoted at the end of this section.

Splashed Ink. *See* TECHNIQUES, *P'o-mo*.

Spilled Ink. *See* TECHNIQUES, *P'o-mo*.

Subjects. The Chinese love of classification has resulted in a number of different schemes at various times, but all may be reduced to a basic five classes. These are *Shan-shui*, landscape; *Jên-wu*, portraiture, figure and genre painting; *Ch'in-shou*, birds and animals, and *Hua-hui*, flower painting. These last two often combine to form another class *Hua-niao*, flowers and birds. *Jên-wu* includes religious painting but Buddhist and Taoist painting has

often formed a class of its own under the term *Tao-shih*, Taoist and Buddhist.

Tao-shih. *See* SUBJECTS.

Techniques. These have been carefully classified by the Chinese and the most important are given here by their Chinese names.

Hsieh-i, free sketch, spontaneous expression; usually in ink but late examples may just as easily be in colour.

Kung-pi, meticulous brush-work; confined to painting in colours.

Ch'ing-lu, blue and green painting; landscape only, and this is always *kung-pi*.

Chin-pi shan-shui, gold and green landscape; gold outlines.

Shui-mo, ink painting, no colour.

P'o-mo, 'broken ink'. Having outline and general configuration of rocks defined to give modelling and depth.

P'o-mo, 'spilled ink', 'splashed ink'. Painting with broad full strokes, often with the side of the brush.

Kan-pi, 'dry brush', a very sparing use of ink in ink painting.

Fei-pai, 'flying white', the brush so used that the hairs separate in ink painting and leave streaks of untouched white ground, imparting a light, airy quality. Common in bamboo, and bird and flower painting.

Mei-ku hua, 'boneless painting', painting in colour without outline.

Chih-hua, 'finger painting'. The fingers and nails used for painting instead of, or in addition to the brush.

T'i-pa. *See* COLOPHONS.

Tzŭ-ch'ing Chüan. *See* PORCELAIN BLUE SILK.

Wrinkles. In Chinese *ts'un*. Shading, modelling; the name given to the distinctive modelling and texture of tree trunks, rocks and mountains. According to some sources there are about 25 types of wrinkles or strokes. For a few of the most important *see* BRUSH STROKES, Rocks.

Yüan-chin, 'far and near', perspective.

PAINTING

RECOMMENDED BOOKS

BINYON, L. *Painting in the Far East*. London, 1913.

CAHILL, J. *Chinese Painting*. Lausanne, 1960.

CAHILL, J. *Hills beyond a River: Chinese Painting of the Yüan Dynasty, 1279–1368*. New York & Tokyo, 1976.

CAHILL, J. *Parting at the Shore: Chinese Painting of the Early and Middle Ming Dynasty, 1368–1580*. New York and Tokyo, 1978.

CAHILL, J. *The Restless Landscape: Chinese Painting of the Late Ming Period*. Berkeley, 1971.

CHIANG YEE. *The Chinese Eye*. London, 1960.

COHN, W. *Chinese Painting*. London, 1951.

EDWARDS, R. *The Art of Wên Chêng-ming (1470–1559)*. Ann Arbor, 1976.

JENYNS, S. *Background to Chinese Painting*. London, 1935.

KUO HSI. *An Essay on Landscape Painting*. London, 1935.

LEE, S. E. *Chinese Landscape Painting*. Cleveland, 1962.

MARCH, B. *Some Technical Terms of Chinese Painting*. Baltimore, 1935.

ROWLEY, W. *Principles of Chinese Painting*. Princeton, 1947.

SIRÉN, O. *The Chinese on the Art of Painting*. Peiping, 1936.

SIRÉN, O. *A History of Early Chinese Painting*. London, 1933.

SIRÉN, O. *A History of Later Chinese Painting*. London, 1938.

SIRÉN, O. *Chinese Painting: Leading Masters and Principles*. London, 1956-8. 7 vols.

SULLIVAN, M. *The Birth of Landscape Painting in China*. Berkeley and Los Angeles, 1962.

UNIVERSITY OF MICHIGAN *The Painting of Tao-chi, 1641-ca. 1720*. 1967.

WHITFIELD, R. *In Pursuit of Antiquity*. Princeton, 1969.

MISCELLANEOUS ☆

Altar Set. An altar set usually consists of a cauldron on three or four legs, two vases, or beakers, and sometimes two pricket candlesticks. Sets are made in bronze, porcelain, jade or lacquer, the last two materials being used probably only from the 18th century onward.

Bantam Work. A term derived from the name of the transshipping port of Bantam in Java, which was used by the Dutch East India Company. *See* COROMANDEL LACQUER.

Canton Enamels made their appearance early in the 18th century in imitation of those of Limoges, the enamel colours being painted on a copper base. The Chinese term *fa-lan* is the correct term in that language, but it may also be found in contexts where enamelling on porcelain is clearly intended.

Carved Lacquer, produced from the T'ang Dynasty onward, but the precise date of the origin of this technique is uncertain. The numbers of layers of lacquer (q.v.) varies; there may be as many as 100, or even more, and they may also be in differing colours.

Champlevé, enamelling on metal, the areas to be enamelled being recessed. After firing the enamels, the object is rubbed down and polished, and the exposed metal surfaces are then gilt.

Ch'ao-fu, court dress, a term inclusive of all types of official dress worn on state and ceremonial occasions, by both men and women.

Ch'iang Chin. Incised lines in lacquer, dressed with raw lacquer, upon which is then impressed gold or silver foil with a piece of cotton, the excess on the polished, unlined surface then being wiped off. A technique of unknown

origin, but practised at least as early as the Sung Dynasty.

Cinnabar Lacquer. Brilliant red lacquer, the colour being derived from the sulphide of mercury known as vermilion.

Cloisonné, enamelling on metal. In this type of enamelling the designs are formed by soldering wires, usually copper wires, to a metal base, so that cells (*cloisons*) are created. The cells are then filled with enamel pastes of the appropriate colours and the object is fired in a muffle kiln. After firing the rough, uneven surface is rubbed down and polished; finally the wires, exposed by the polishing process, are gilt, together with any other exposed metal surfaces. *See also* CHAMP-LEVÉ.

Coromandel Lacquer. A name given to screens, chests and panels with designs cut through three or four layers of lacquer to the raw wood foundation, which is then painted with brightly-coloured pigments bound with lacquer. The polychrome decoration is left unpolished against the glossy black, brown or red polished ground. This type of lacquer was first made for the Chinese market, but proved popular with the foreign merchants. This resulted in great quantities being produced, much of it of indifferent quality. The type gains its name from the Coromandel Coast of south-west India, where it was trans-shipped and handled by merchants who had little, if any, interest in its place of manufacture. Technically there seems little difference between Coromandel and what used to be known as 'Bantam work', a term now obsolete.

Dragon Robes. A general term for dragon-decorated robes worn by the emperor, the imperial clansmen and senior officials of the administration, on all official and state occasions. These robes were also worn by the empress, the women of the imperial household and the wives of those officials entitled to them.

Guri. A term used in European texts to describe carved lacquers in which alternate layers of different colours are displayed in scrolling and 'cloud collar' designs. The term is of Japanese origin, and used to describe a whirligig pattern, but in connection with lacquer is meaningless to most Japanese. There is no generally accepted Chinese term to describe this type of polychrome effect, in which coloured layers are deliberately displayed by the bevelling technique used in carving the design.

Heidatsu is a Japanese term for the technique of setting gold and

silver foil decorations in a bed of lacquer, and then lightly incising the details. The Chinese term is *p'ing-t'o*, but this is less familiar than the Japanese term. The technique was particularly popular in T'ang times, but the date of its origin is not known.

Hsi-p'i, marbled lacquer. Lacquer in which there are layers of different colours, that show as the result of polishing, or of wear, and also as the result of carving. The term has been interpreted as 'rhinoceros skin' or 'tiger skin' lacquer. *See* GURI.

K'o-ssŭ. A very fine silk tapestry technique, which appears to have developed during the latter part of the T'ang Dynasty or perhaps a little later. Early examples of pictures, especially of birds and flowers cannot be dated before the Sung Dynasty and are usually small. By the 18th century large, complex pictures and whole court robes were made using this technique.

Lac Burgauté. Lacquer in which is embedded mother-of-pearl in chips of varying size; patterns and decorations may be very complex, and the final effect, when polished, is exceptionally pleasing. An expensive and difficult technique invariably carried out on a black lacquer ground.

Lacquer is the natural sap of the tree *Rhus vernicifera*, which becomes highly resistant to chemicals, damp and considerable heat, after proper preparation, and when dried in a humid atmosphere. It may be stained with almost any colouring matter, and applied in thin layers to most surfaces; it may be painted, carved or inlaid. Each layer must be allowed to dry before the next is applied; coats on a single piece may number as many as 100 or more. The Chinese have admired and used the material from very early times, probably first as an inlay in bronze and then from about the 5th century B.C. for vessels and utensils of many kinds. Early examples carry painted decoration; carved lacquer is not certainly known before the T'ang Dynasty.

Lo-tien. The technique of inlaying hardwood with designs in brass or silver wire. It is perhaps of Ming origin.

Lung P'ao. *See* DRAGON ROBES.

Magatama. A Japanese term meaning a curved, comma-shaped bead of stone or glass. This type of bead occurs mainly in Korea and Japan, but may be found occasionally in tombs of the Han period.

Mang P'ao. Robes of *Mang* type. *Mang* is ordinarily a python or large snake, but in this

年製 洪武
Hung-wu
1368-98

Yung-lo
1403-24

年製 永樂
Yung-lo
1403-24

德年製 大明宣
Hsüan-tê
1426-35

化年製 大明成
Ch'êng-hua
1465-87

治年製 大明弘
Hung-chih
1488-1505

德年製 大明正
Chêng-tê
1506-21

靖年製 大明嘉
Chia-ching
1522-66

慶年製 大明隆
Lung-ch'ing
1567-72

曆年製 大明萬
Wan-li
1573-1619

啟年製 大明天
T'ien-ch'i
1621-27

年製 崇禎
Ch'ung-chên
1628-43

REIGN PERIOD MARKS. MING DYNASTY

治年製 大清順

Shun-chih 1644-61

熙年製 大清康

K'ang-hsi 1662-1722

正年製 大清雍

Yung-chêng 1723-35

隆年製 大清乾

Ch'ien-lung 1736-95

年製 嘉慶

Chia-ch'ing 1796-1820

光年製 大清道

Tao-kuang 1821-50

豐年製 大清咸

Hsien-fêng 1851-61

治年製 大清同

T'ung-chih 1862-73

緒年製 大清光

Kuang-hsü 1874-1908

統年製 大清宣

Hsüan-t'ung
1909-12

年製 洪憲

Hung-hsien 1916
(Yüan shih-k'ai)

REIGN PERIOD MARKS. CH'ING DYNASTY

instance it is generally a four-clawed dragon. *Mang* robes are always decorated with nine of these, and are worn by the emperor's sons, imperial clansmen and all members of the civil service, and the wives of men in any of these three categories. Those worn by the emperor's sons, however, had five-clawed dragons, which were always against a bright orange-yellow ground, while all other persons wore a stipulated four-clawed type against a dark blue ground.

Nien Hao. Reign period, a term used of date marks incised, painted or otherwise added to an object, whatever its material. Such marks usually consist of four or six characters, and do not normally occur before the 15th century. *See* Plates pages 128, 129.

Peking Knot. An embroidery term for a decorative knot, which is a Chinese variation of the well-known 'French Knot'.

Peking Lacquer. A name given to the finest quality carved lacquer, generally believed to have come from the imperial factory.

P'ing-t'o. *See* HEIDATSU.

GENERAL

RECOMMENDED BOOKS

ASHTON, L. & GRAY, B. *Chinese Art.* London, 1951. (Revised ed.)
BACHHOFER, L. *History of Chinese Art.* New York, 1946.
BURLING, J. & A. H. *Chinese Art.* London, 1953.
BUSHELL, S. W. *Chinese Art.* London, 1924. 2 vols. (Revised ed.)
CAMMANN, S. *China's Dragon Robes.* New York, 1952.
CARTER, D. *Four Thousand Years of Chinese Art.* New York, 1951.
CREEL, H. G. *The Birth of China.* Cambridge, 1961. (Reprint.)
FEDDERSEN, M. *Chinese Decorative Art.* London, 1961.
FERGUSON, J. *Survey of Chinese Art.* Shanghai, 1940.
FITZGERALD, C. P. *China: A Short Cultural History.* London, 1951.
GARNER, SIR HARRY. *Chinese and Japanese Cloisonné Enamels.* London, 1962.
JOURDAIN, M. & JENYNS, S. *Chinese Export Art.* London, 1952.
MUNSTERBERG, H. *A Short History of Chinese Art.* East Lansing, 1949.
ORIENTAL CERAMIC SOCIETY. *Arts of the Ming Dynasty.* London, 1958.
ORIENTAL CERAMIC SOCIETY. *Arts of the Sung Dynasty.* London, 1960.
SICKMAN, L. & SOPER, A. *The Art and Architecture of China.* Harmondsworth, 1956.
SULLIVAN, M. *An Introduction to Chinese Art.* London, 1961.
WATSON, W. *Style in the Arts of China.* Harmondsworth and New York. 1974.
WILLETTS, W. *Chinese Art.* Harmondsworth, 1958. 2 vols,

PERIODICALS

Antique Collector, London. Vol. 1 —, 1925 —.
Apollo, London. Vol. 1 —, 1925 —.
Archives of the Chinese Art Society of America, New York. Vol. 1 —, 1945 —.
Ars Orientalis, Washington & Michigan. Vol. 1 —, 1954 —.
Artibus Asiae, Ascona, Switzerland. Vol. 1 —, 1925 —.
Bulletin of the Museum of Far Eastern Antiquities, Stockholm. Vol. 1 —, 1929 —.
Burlington Magazine, London. Vol. 1 —, 1903 —.
Connoisseur, London. Vol. 1 —, 1901 —.
Far Eastern Ceramic Bulletin, Published in the U.S.A. for the Far Eastern Ceramic Group. Nos. 1-43. 1948-1960.
Oriental Art, London. Vols. 1-3, 1948-1951. New Series, Vol. 1 —, 1955 —.
Transactions of the Oriental Ceramic Society, London, Vol. 1 —, 1921 —.

SOCIETIES

The Chinese Art Society of America in New York.

The Oriental Ceramic Society in London. 31b, Torrington Square, London, W.C.1.

The Oriental Ceramic Society, in spite of the limitation suggested by its name, is concerned with all aspects of Chinese art. The catalogues of the Society's exhibitions are valuable.

COLLECTIONS

of Chinese material in museums and galleries open to the public in Great Britain

Bristol: *Bristol City Art Gallery and Museum.* Ceramics from the Schiller collection, together with a growing general collection.

Burnley, Lancs.: *Towneley Hall Art Gallery and Museum.* Later Chinese ceramics and jades.

Cambridge: *Fitzwilliam Museum.* Ceramics and jades well represented.

Durham: *Gulbenkian Museum.* Bronzes, jades and hardstones, ivories, ceramics and textiles. A new and growing collection of oriental arts.

Edinburgh: *Royal Scottish Museum.* An important general collection, strong in lacquer and enamels.

Leeds: *Temple Newsam.* This is a general art collection, which includes good late ceramics.

London: *British Museum.* The finest collection of bronzes, early jades and early ceramics in the country, it also includes the Stein collection of Buddhist painting from Tun-huang. One of the most important general collections.

Percival David Foundation of Chinese Art. The University of London's collection of imperial porcelains from the 10th to the 18th centuries.

Victoria and Albert Museum. The largest reference collection of ceramics, textiles and late metalwork. One of the most important general collections.

Manchester: *Wythenshawe Hall.* Ceramics.

Oxford: *Ashmolean Museum.* An important collection of bronzes, early white pottery and porcelain, early Yüeh ware and celadon. A general collection that is growing.

Port Sunlight, Liverpool: *Lady Lever Art Gallery.* An important collection of Ch'ing porcelains and snuff bottles in various materials.

Sheffield: *The Graves Art Gallery.* Ivories from the Grice Collection.

INDEX

57$\frac{20}{1}$ K

25/187